D0484010

glo

glop

GOOP PARODY

glop

NONTOXIC, EXPENSIVE IDEAS
THAT WILL MAKE YOU LOOK
RIDICULOUS AND FEEL PRETENTIOUS

Gabrielle Moss

DEY ST.
An Imprint of WILLIAM MORROW

DEY ST.

HarperCollins books may be purchased for educational, business, or sales promotional use. For information, please email the Special Markets Department at SPsales@harpercollins.com.

FIRST EDITION

Designed by Vertigo Design NYC

Library of Congress Cataloging-in-Publication Data has been applied for.

33614057768235 ISBN 978-0-06-265799-2

16 17 18 19 20 RRD 10 9 8 7 6 5 4 3 2 1

For Jesse. Who else?

Achieve

Exist

Create

Gain

Look At

What Is Glop?

Recently, at an after-party celebrating the opening of a new chain of ultra-luxe, high-end sweat lodges, I was having a wonderful time chatting with Dave Grohl, Melinda Gates, Naomi Campbell, Justin Trudeau, and the shark from *Finding Nemo*. We were having great wine, great conversation, and great paleo "pizzatizers" (cucumbers, bee pollen, and a glass of strained water), when Dave asked me what my lifestyle website, Glop, was. And I really had to think for a moment.

I first rose to prominence as an acclaimed actress who appeared in award-winning films, as well as a selfless humanitarian who occasionally appeared in slightly less award-winning films as a personal favor to Jude Law. But while those were careers, Glop is my *passion*. And passions can be a bit more difficult to explain. So I began to ponder. What, really, is Glop?

Glop is a business and a website, of course. But Glop is also a feeling.

Glop is realizing that if you pick the right expensive organic eye cream, you can finally become a tall, thin, wealthy blonde WASP who fits seamlessly into the top tiers of high society, *but also* seems like she's tried ayahuasca (not, like, a "drug addict" amount; just a tiny bit to help quit smoking).

Glop is knowing in your heart that if you finally pay attention to all the tiny decisions that make up our lives—what to eat, where to buy your cashmere yoga pants, which juice cleanse will remove the most toxins from both your body *and* your cashmere yoga pants—you can create an existence that you are proud of; so proud that you eventually transform from a regular person into a person who has been seated next to Bono at a 42-course seitan tasting dinner held in a sex dungeon deep beneath the North Pole.

Glop is understanding that if you're able to carefully and intelligently monitor the things that your children eat, play with, and do, they'll grow up to be happy, healthy, and strong, and live beautiful lives that are never marred by rumors that they only shower with bottled water that has been stored in Emma Thompson's garage.

<div align="center">

Glop means all this and so much more to me and the people I share it with.

</div>

When I turned back to Dave to tell him all of this, I realized that I was actually no longer at the party. In fact, I was midway through a Concorde ride back to my cozy third London mansion (my children, Philamena Hoobastank and Chard, playfully call it our "Wednesday house").

But then I realized, this information shouldn't be confined to dinner party chit-chat—I needed to share it with you, the people who make Glop matter. In the pages that follow, I'll share my favorite recipes, detoxes, activities, juice cleanses, vacation destinations, beauty tips, destination juice cleanse-detoxes, and a selection of hand creams that will open your third eye—the very things that make me *me*, and can now help make you me (and, of course, every item mentioned herein is available for purchase on our website).

Like Glop the site, *Glop* the book is divided into five categories that cover the key areas in life:

Achieve

TAKING CARE OF YOUR BODY, INSIDE AND OUT (YOU REALLY SHOULD ALREADY HAVE DONE ALL THIS STUFF, BUT I WON'T TELL)

Exist

SELF-DISCOVER ALL THE THINGS YOU WERE DOING WRONG, SIMPLY BY BEING YOURSELF

Create

STUFF YOU GET TO TAKE CREDIT FOR!

Gain

IT'S NOT CONSUMERISM, IT'S MINDFUL ACCUMULATION

Look At

MY PICKS FOR THE MOST GRIPPING, ABSOLUTELY MUST-SEE CULTURE FROM AROUND THE WORLD THAT ONLY I KNOW HOW TO GOOGLE

Sometimes people ask me, "Hey, don't you think these categories overlap a lot?" Usually, right after they ask, the alarm on my phone goes off, indicating that it's time to take some of the chakra-balancing supplements I made from a rare tropical fish that isn't technically endangered because no one except me has heard of it. By the time I'm finished and am able to respond to them, they've gone. Crisis averted! ·

Dance like someone is watching (because I am),
G

A BRIEF ENTREATY TO EXERCISE CAUTION

Please don't eat the things this book tells you to eat. Don't wear the things this book tells you to wear, go to the places this book tells you to go, buy the things this book tells you to buy, or otherwise engage in any of the activities recommended in this book. They're not only potentially hazardous to your health—they won't make you any more like me, either. Sorry. You're just not on my level.

Prudently yours,
G

glop

BEAUTY

During the Neolithic era (10,000 B.C.–2000 B.C.), the average human life expectancy was only 20 years, and most of that time was preoccupied with the search for food and shelter. This meant that most people had only a very limited amount of time to devote to practices that we now consider the pillars of civilization, like applying foot contouring makeup and engaging in hair follicle maintenance.

Unlike our ancestors, we get to enjoy the stability of private property, the security of a formal legal system, and the hydrating refreshment of coconut water. But when it comes to beauty, we're no better off.

At first blush, this makes no sense—with more technology, knowledge about the world, and access to water that is typically free of mastodon urine, modern people should be able to develop beauty routines that run circles around those of our predecessors. But our ancient foremothers weren't constantly rushed, like we are today—they had the time to do things the best way, not just the fastest way. And they maintained their beauty with wholesome, organic products like polished stones, sun-baked mud bricks, and astringents made from the ground-up shells of the era's terrifyingly gigantic millipedes.

Meanwhile, in our modern era, we seek beauty with all sorts of chemicals and additives that may quickly pop a blackhead or smooth a crow's foot today, but will make us—and our earth—pay tomorrow. For example, did you know that the average store-bought "quick fix" facial moisturizer contains ingredients that can cause depression, chin dysmorphia, searing gas pain, and a condition called "sideways peeing"—as well as what the FDA considers an "acceptable" level of seagull ejaculate? I don't know about you, but I think I'm the best judge of how much seagull ejaculate is right for my family, *not* the federal government.

But giving in to this poisonous march of progress isn't our only option. As long-time readers of Glop know, I'm as devoted and passionate about finding all-natural solutions to our most pressing beauty dilemmas as I am about teaching you how to steam a flawless batch of mussels or execute the perfect 3-point turn to avoid driving past a Costco—maybe even more passionate. Which is why, in this chapter, I am committed to sharing all my most treasured natural beauty solutions and secrets with you—no matter how much time they take or how much mastodon urine they require.

How to Make Your Hair Say: "I Care about Water Quality in the Developing World, but Not in a Depressing Way"

We all love the look and feel of sexy, classic hair that has bounce, volume, and clearly communicates our beliefs regarding worldwide resource access issues in a positive, upbeat way. But while it's easy to walk out of a salon with waves that absolutely shout, "Let's discuss UNICEF's report on Water, Hygiene and Sanitation in a chill, relaxed way that won't make you feel like anyone is getting mad about how often you water your lawn," it's much tougher to achieve that look at home, especially during the busy work week.

Or is it? Glop's favorite styling expert, Marjorie Huppington-Worthington, of Los Angeles's Marjorie Huppington-Worthington Salon—the world's only certified all-green salon located inside a solar-powered luxury children's treehouse—has some simple tips about how to get hair that says "I'm socially engaged! But not someone who is going to be a downer if you get plastic bags at the grocery store and then just throw them away, I get that we're all just here to hang":

After your shower, towel dry and divide hair into four sections.

———————

Roll hair into hot rollers and let sit 1.5 minutes.

———————

Unroll, and mist with a light, flexible finishing spray.
We like the Marjorie Huppington-Worthington Salon's
"Zuma Breeze Spray," which is made from actual breeze that
Marjorie hand-bottles while tanning on Zuma Beach.

———————

Using a round brush, flip curls slightly outward for that "Salaman Rushdie
once talked to me about filtration systems at a party" vibe.

———————

INSIDER TIP

Flip your head upside down and then back up before
leaving the house for a looser look.

Looking for a finish that makes it clear you're here to discuss ideas in an unaggressive, purely intellectual way, and won't try to make anyone sign a petition at the end? Simple! Just work some coconut oil through your tips.

Natural Botox:
Mummification and Lying
Motionless in a Sarcophagus

A decade ago, I caused quite a commotion at a film premiere when I showed up in a sleeveless Marchesa gown with resin-soaked bits of linen clinging to the backs of my upper arms. Tongues began wagging in the press, of course—people speculated that it was due to some kooky new religious cult I had joined, or that I had a new lover whose "thing" was tagging his mate with resin-soaked linen as a way of declaring sexual ownership. Both those ideas are ridiculous, of course—*that* particular lover's method of declaring sexual ownership is a secret that Jenny Garner and I will be taking to our graves, thanks very much. The reality was much simpler: those paparazzi shots caught me at the beginning of my long, life-affirming health and beauty love affair with being mummified and lying motionless in a sarcophagus.

When it comes to natural health and anti-aging strategies, no one has greater ideas than the ingenious ancient Egyptians. They knew that you can harness the power of gravity—much maligned as a negative force that makes our faces sag, bellies pouch, and cars roll into the front window of Barneys because we forgot to put the parking brake on or turn it off all the way or something—to actually be our friend in the fight against aging.

But this *only* works if we harness gravity's power dynamically. That means we need to utilize the contrarian wisdom of the Egyptians—instead of *fighting* against gravity, we need go with gravity, and surrender to it completely by lying absolutely motionless in a large stone tomb. Through a combination of natural anti-aging properties, "sarcoffing" helps keep our skin supple, can banish cellulite, and will preserve our vital organs for the long and arduous trip to the afterlife. We can also give the experience an extra "pop" by binding our bodies completely in resin-soaked linen rags, to lock in the skin's moisture and essential juices.

If you can't find an authentic ancient Egyptian sarcophagus, don't worry! Designer Anjelica Homonucleus has a great new line of sarcophagi in the $10,000–20,000 range—lovingly created from repurposed vintage shipping containers, they all come Bluetooth-equipped, so that you can still run your business, keep on top of your family life, or just catch up on podcasts while supine. I personally like to enjoy the respite and silence that my sarcophagus provides, and take the opportunity to binge-watch my body revitalize itself.

My Best Organic Beauty Secret:
Being Born to Extremely Attractive Parents

If you're anything like most women I know, your bathroom is probably littered with failed fad beauty products—creams that promised firmer jawlines but delivered only clogged pores, useless powders that tried and failed to whiten your teeth, eye shadows that were supposed to show that you were still young and hip but instead just led to a two-page spread in *Us Weekly* where a bunch of comedians said you looked like you had cholera.

Almost every woman has these "beauty fails" locked up in her cabinets. Yet despite all the money, heartbreak, and light-to-medium chemical burns we've experienced at the hands of our products, we still hold out hope that

somewhere, within Nature's bounty, there is a beauty game changer—a multi-purpose product that will answer all your aesthetic prayers in a safe, nontoxic, natural way, no dangerous additives or confusing ingredient lists required.

Today, I am pleased to share my most treasured organic beauty tip, presented for the first time exclusively to Glop readers! This one has been my go-to move since I was an awkward, gawky teen modeling for Dior, and it's served me well—and I am finally ready to pass this totally transformative knowledge onto you:

Be born to extremely attractive parents.

It's the kind of simple, intuitive, yet totally life-changing beauty secret that our toxin-pushing cosmetics industrial complex just doesn't want regular women to have. It's also proof that, with the raw, unvarnished power of Mother Nature by her side, every woman has the ability to banish the signs of premature aging, get the creamy skin she's always dreamed of, and become engaged to Brad Pitt for what was it, one, two years? It was so very long ago (but it was definitely two years).

HERE'S HOW TO PUT THIS PLAN INTO IMMEDIATE ACTION:

Find two parents who have made their careers as models and/or actors.

———

IF TWO MODELS AND/OR ACTORS ARE NOT CURRENTLY AVAILABLE, YOU MAY SUBSTITUTE ONE (1) OF THE FOLLOWING:

Host/hostess of an ultra-high-end sushi restaurant

———

Regional beauty pageant champion (Northeast only!) ➤

———

Personal trainer

Hero firefighter (40 years old & under)

Elite dermatologist in a coastal area

Flight attendant

Extremely successful real estate agent who wanted to be a model and/
or actor but never had the familial support, and then had to pay their own
way through college, and well, here I am now, it's not a bad life, I guess

Former model

Remember, however, that only one substitution is advisable; drawing two
parents from the substitution list puts you at risk for serious birth defects like
facial moles or naturally curly hair.

> NOTE: This plan is not a substitute for daily exercise, mindful
> meal planning, or having someone describe what carbs taste
> like while you hold your palm above an open flame.

What's Wrong with Your Vagina?!

We try to do everything we can to stay on top of our beauty regimen—we schedule regular appointments for colon hydrotherapy and no-contact mind-massages; we have a licensed professional whom we trust with our anal bleaching, anal coloring, and anal double-process highlighting needs; and we make sure to always get plenty of rest, vitamin D, and unpasteurized snake milk. But while we're focused on these essentials, it can be easy to let other, less visible but still important beauty concerns fall by the wayside. I speak, of course, of your mons Venus, your flowering zucchini plant, your octopus's garden, your Sting's private island in Belize: your vagina.

Did you know that even if your vagina feels good and has been given a clean bill of health by a medical professional, there can still be something terribly wrong with it? Clinical vagina stylist Blair Wintch estimates that, because ➤

these problems do not impact the vagina's health or functionality and typically go undiagnosed by doctors who think they "don't exist," up to 90% of American women will never be aware of the fact that they are suffering from a serious vaginal ailment: lazy vagina. What is "lazy vagina"? Simply put: it's a lady luge that refuses to carry its own weight, and as a result has become soft and sloppy-looking.

Here's the good news: suffering from this ailment doesn't have to interfere with your vagina's right to a picture-perfect future. You can get back your firm, stylish vagina—or even get one for the first time—by utilizing a single ancient health technique that has been helping women for millennia: holding your pee.

This traditional healing practice not only shapes up our junk and helps us fully absorb the nutrients in the healthful liquids that we consume; it also detoxes the urethral vestibule and actually *alkalizes* the urerethral restibule, which I think is something we can all agree that we need more of in our lives.

I talked to Juliette Horace-Goblin, my urine coach, who had these top tips for women interested in beginning their dynamic pee-holding journey:

DON'T LESSEN THE AMOUNT OF LIQUID YOU'RE CONSUMING EACH DAY.

This is a common newbie mistake! You still need your standard 8 to 10 glasses of water daily to stay healthy and hydrated.

PRACTICE TENSING YOUR KEGELS.

The same muscles you may have already been toning in order to improve your sex life. You'll want to do reps in sets of 10, starting with 5 sets a day and moving up to 400 sets a day. If you have a moment of kegelular failure, don't worry—it happens to everyone at the start. My advice would be to pack

an extra set of pants when you're new to this practice, as well as a sense of humbleness and a determination to learn from your flaws (especially the pee-based ones). You may also want to avoid fountains, just as you get your bearings.

A lot of new practitioners ask me, "Am I allowed to pee at all?" Yes, of course you're allowed to pee! Urine is an important part of the body's natural detox-ification process; we're just turbo-charging it. You're allowed to pee once a day, between 7:45:03 and 7:45:23 pm GMT. So make it count!

Over time, you'll see your body—and life!—change as a result of a dedicated pee-holding practice. Your sleek, powerful kegel muscles will begin to strain against the seams of your power suit, or peek out of the bottom of your short-shorts. I recommend buying outfits to highlight them, as they are a symbol of simple yet vibrant feminine power—think of them like Angela Bassett's incredible arm muscles.

When used correctly and responsibly, dynamic pee-holding not only improves the look and feel of our vaginas—it improves our health and enriches our relationships with our partners and ourselves.

And though a very small percentage of women who engage in a dynamic pee-holding lifestyle die each year, I can assure you that is because they didn't properly warm up, were not pure of heart and soul, or ate wheat products at some point. Or maybe they were fatally hit by a car and just happened to be holding their pee at the same time, so it was registered as a pee-holding-related death—there's just no way to know.

All you do know is that as you commit to taking that iced matcha green tea cooler you're currently sipping and just keeping it in, a health journey of a thousand steps begins right now—with one held pee.

DETOXES

Of course, it's not enough to just stop putting toxins on your skin—in order to achieve real health, you've also got to get them out of your colon! Whether you're rebooting your body after a few weeks of dietary excess around the holidays, rebalancing your chakras after an almond-milking session gone bad, or simply offsetting exposure to your friend Sasha's children who attend public school, regular detoxes are an essential health tool.

I first discovered my passion for detoxes in college. Thanks to a jovial prank executed in the spirit of fun by my old school chum Chloe, I got a paint can stuck on my head for eight days. During this time period, I was only able to fit a small range of foods under the brim of the paint can—namely rainwater, tomatillo rinds, and unbleached cotton—but when I was finally able to pry the can off, I was shocked by the amazing changes my time off from "food" had given me. The benefits to my mind and body were very real—so real that I've continued to start a thrilling new detox every 72 hours or so in the years since.

You might wonder how you could possibly come into contact with so many toxins (especially if you're already following my beauty advice). The sad answer is that our modern lifestyles are absolutely full of toxins—nearly everything we come into daily contact with, from Egyptian cotton sheets to 8-carat diamonds to yacht paint, is dangerously noxious. And if we don't regularly purge our systems of these toxins, the results can be bleak. Many people claim that toxins are specious, scientifically dubious nonsense designed to scare the ignorant. But if that's true, why do so many Americans suffer from the following toxin-related ailments: acne, depression, taxes, third nipples, yeast varnicles, brain dumbness, fourth nipples, reverse kegels...the list goes on and on, and it's terrifying.

You may currently be living with some of the problems I've listed above, because you think that this is simply the hand you've been dealt in life. But that is absolutely not true. A great detox won't just solve your physical ailments—it will leave you looking and feeling great, and experiencing benefits that you may think are beyond your reach, like reduced belly fat, increased glandular lucidity, some cow telepathy, and a small walk-on role on *Royal Pains*.

The five cleanses below were designed with the help of Dr. Kate Fugelchorn, an internist I met who also runs an invitation-only pedicure salon in Gstaad. Dr. Fugelchorn's revolutionary spa-based approach to health flies in the face of repressive Western medicine, and embraces traditional approaches that believe the body must take periodic breaks from making poop, because poop is gross.

There's a cleanse for every body and soul. No matter where you are on your personal health journey, there's an invigorating new method for you to avoid eating food and detox like a pro for a week.

Raw Raw Honey Detox

If you, like most Americans, are used to buying your "food" from "stores," you might have seen raw honey, but wonder what *raw* raw honey is. Well, it's exactly what it sounds like—honey in its natural state, before it has been treated with preservatives, heated, pasteurized, or looked upon by a poor person. Clearly, "raw" honey sold in stores simply cannot be guaranteed to meet these standards, so I implore you to make your own.

This is a great beginner's detox —it is much less harsh than a more traditional detox, where you only consume thoughts about polenta. And it can also be created entirely from materials you already have lying around your own api-ary! If you don't have an apiary, don't worry—you can easily turn your second greenhouse into an apiary.

In order to ensure that your honey is of the highest possible grade, you'll need to make sure your beekeeper attended a university within the top two tiers of the *U.S. News & World Report* rankings, with a minimum of one semester abroad, though one year is preferred (Asia, South America, or Africa only—studying in Europe is so hacky). Take my beekeeper, Jace, who got into Brown, but chose Vassar because of its smaller class sizes. He did his year abroad studying contemporary dance in Malaysia.

YOU'LL NEED:

3 gallons of raw honey for each of the seven days of the detox

(21 gallons total, but honey must be gathered fresh each day—stockpiling it would be cheating!)

DETOX DETAILS

For the next seven days, eliminate all foods and beverages from your diet; in their place, eat or drink one half gallon of *raw* raw honey. Also eliminate all film or television viewing from your daily life; in their place, just look closely at the honey, which has a rich amber hue reminiscent of many network television programs.

If you feel your kidneys shutting down, don't worry; that's a sign that your body is expelling the toxins.

When your urine becomes a viscous golden rope, you're all done (as long as you're on Day Seven, of course)!

HINT: If you don't have the time to follow this or any other detox yourself, get your assistant Liz to do it for you (I call all of my assistants "Liz"—I find that it's easier for both of us that way).

Raw Ice Detox

Commercially produced ice is absolutely full of toxins, which prevents us from absorbing most of the nutrients present. With all the preservatives and nitrates most stores pump into their ice, you might as well be eating a blueberry, for goodness sake!

But when we're able to consume ice in its raw state, as Nature intended, we can really get to the good stuff—raw ice is absolutely chock-full of "good" fats, R vitamins, and omega-eleventeenths, making it one of my favorite "superfoods."

I first learned about this detox while summering at Tilda Swinton's castle, which is located on Enya's yacht. The local peasants introduced us to their traditional practice of consuming "ice"—I was hesitant at first, but one mouthful, and I was hooked! This is one detox that is as delicious as it is nutritious.

Tilda likes to spice up her raw ice with a light dusting of chia powder, but that is wrong and Tilda will receive her punishment in Hell where she belongs.

YOU'LL NEED:

87 pounds dry-harvested raw ice from off the coast of Languedoc

DETOX DETAILS

12 times each detox day, follow this relaxing ritual:

Place the ice in a stainless steel pot.

Turn burner on high until the cubes have converted to vapor.

Inhale deeply.

Ultra-Refined
Vibrance Powder Detox

Here's a simple one for you busy working moms out there. You know who you are—you're the ones who write in to me each week about how Glop detoxes are too "expensive," "time-consuming," and "fatal" for the average woman to utilize.

And I've been listening! I know that time is at a premium for many of you reading this who are trying to balance work and family. While there are no shortcuts when it comes to health, there are a few supplements we love that can really kick-start a new healthy lifestyle program.

The right supplement can help cover the nutritional gaps that turn up in even the most carefully crafted diet plans—so with the help of Dr. Fugelchorn and several former touring members of Santana, I've developed a detox for

people on the go that gets results, rebalances energy, and will help you develop the "good" heart palpitations that are a cornerstone of any effective detoxification plan.

YOU'LL NEED:

One gram of Ultra-Refined Vibrance Powder for each day of the detox

Note: *We'd love to sell Ultra-Refined Vibrance Powder on the Glop website, and we're presently in talks with several current and former U.S. senators in hopes of making that dream a reality! But until that day, you can easily obtain it from your beekeeper, or your beekeeper's roommate (you know, the one who never has his shirt on). Failing that, try asking any employee at whichever bar in your town hosts the most bachelorette parties.*

DETOX DETAILS

Start each day by dusting a small makeup mirror ($33) with the Ultra-Refined Vibrance Powder. You'll want to properly plate your Ultra-Refined Vibrance Powder with the assistance of your Amex Black Card, a fish knife that once belonged to Milan Kundera, or another thinly edged tool. Organize it until it is in a nice, neat row. Now look at the mirror very closely...very closely...*soooooo closely*...oops, did you accidentally inhale a bunch of the Ultra-Refined Vibrance Powder? Great! Now you're ready to go!

Repeat this health ritual as needed throughout the day to support your detox experience.

If you can't stop grinding your teeth or talking about how you have this *great* idea for a screenplay that you really need to get to Angelina Jolie because you think she'd really just *get* it, don't worry; that's a sure sign that your body is expelling the toxins.

Edamame-Pods-That-Have-Been-Discarded-by-the-Cultural-Elite Detox

Once you've got the hang of detoxing, and are looking for a bit of a challenge that you can sink your teeth into, this is a fabulous place to start. This detox was created when I was having a hard time after the holidays one year; I had overindulged in wine fumes and cake air, and I was *really* feeling it.

Then, in a stroke of divine inspiration at the start of the Cannes Film Festival, I developed this plan and soon I got my groove back—so much so that I had to be airlifted to Vienna before I even got a chance to go to David Geffen's château to partake of the traditional Gallic diversion of "foosball."

The real reward of this detox is in its complex simplicity—over the course of this week, you'll come to truly understand the rich flavor profile of edamame pods that have been discarded by America's top actors, writers, musicians, and artists in a new way—in addition to reaping health benefits like improved skin tone and "extra" blood.

YOU'LL NEED:

$5,000

Beeper number for "Gary"

DETOX DETAILS

"Gary" (whose real name is definitely *not* Gary) is a discreet professional specializing in the resale of celebrity post-usage foodstuffs on the secondary market. A week's worth of "pods" will typically run you a cool 5K, though Gary and I have a trade-in-kind agreement where I give him 40 stalks of asparagus that I have viewed for 20 minutes each.

I wish I could tell you how to contact Gary directly, but that would be a bit in violation of the broker-detoxer relationship. The best I can do is recommend that you set aside a few hours to hang around in front of the restrooms at the La Jolla Neiman Marcus. Make sure to look inconspicuous, and don't bring any recording devices—if Gary thinks that you are wearing a wire, he will end the transaction with no refunds, and he will be right to.

Locked in a Room with No Doors and No Windows Detox

I adore being a mother. Still, every few months I like to travel apart from my beloved children, Patient Herbivore and Chillax, and escape for a spot of "me time," just to decompress. I like to go hit the open road in my Maybach, listen to some of my favorite raps music, feel the wind blow through my hair, and then get my colon thoroughly irrigated in a gorgeous pastoral setting. It's what keeps me sane.

I discovered this gem of a detox several years ago, while traveling in a former breakaway Soviet Republic on one of these "me time" trips. I had received a hot tip about an innovative new spa in the area from Scarlett Johansson's

nanny, Anne Hathaway. I was about two hours away when, of course, my GPS broke. I pulled up to a large house that seemed to be in the midst of collapsing and knocked on the door. I wanted to see if they'd let me borrow their GPS if I promised to have my assistant mail them a new one when I was done.

But when I finally conversed with the man who opened it—a quietly regal fellow named Clod—I was shocked to learn that *this was the spa!* They had moved several hours outside the city and done away with brutal and unnecessary modern design conventions like floors, in order to provide guests with a more bucolic and rustic setting in which to have their buttholes washed.

I am, more than anything else, an adventuress at heart—so when Clod, who I understood to be the manager, told me about a new detox program he was personally overseeing, I was immediately on board. After spending what felt like hours entering a series of darkened staircases, chutes, and bookcases that were actually secret passages, I got a little woozy. When I came to, I was resting in a sylvan grotto of a room filled with rich, earthy scents, charmingly retro "garage-style" lighting, and no windows, doors, vents, holes, or crevices of any kind.

In this room, which became my home for somewhere between the next 7 and 32 days, I discovered a detox experience beyond what I had previously thought possible. Away from the rush and clatter of my glamorous globe-trotting lifestyle—and with food, water, and human contact thoughtfully withheld by the management—I was able to truly touch the core of what detoxing is really about. I used my time and space there to purify my body, renew my spirit, and astral-project to Moby's house to have a much-needed meeting regarding our summer share in Tulum. It was bliss.

At some point I faded out of consciousness, and when I came to, I was presenting the Academy Award for Best Sound Mixing. *Vogue* noted that my skin looked "luminous," but the real rewards of this detox run far deeper than my pores. I went back to the spa a few months later to try to thank Clod ➤

(and also to find the Amex Black Card that I seemed to have left there), but I couldn't locate him anywhere, and all the villagers told me that the spa where I cleansed had actually burned down with an entire family inside some 50 years ago. Which just goes to show— most of us are blind to the great majesty that exists right under our noses.

YOU'LL NEED:

One room with no doors, windows, or vents
(Rooms with no doors or windows but some vents can be adapted using putty and a belt sander—see the exclusive guide on our site for instructions.)

7 to 32 days

Purified lemon-cayenne water

DETOX DETAILS

Wake up in the room. How did you get here? Is this the afterlife? Will God ever forgive you? Will you ever forgive yourself?

You'll know that the detox has ended when you come to at the Academy Awards wearing a backless Proenza Schouler gown. Reward yourself with a refreshing sip of purified lemon-cayenne water. You've earned it!

HINT: This detox is best comple-mented by some light morning stretching, which helps engage your lymph nodes.

BONUS:
Make sure to check out our site for more great detoxes like:

"Lucid Dream about a Banana" detox

"Long Pig & Sunflower Seeds" detox

"Water from Walden Pond" detox

"Tulips & Dee's Nuts" detox

"Hovering on the Brink of Death until the Last Possible Second & Then Someone Uses Defibrillator Paddles on You" detox

"Only Foods Mentioned in Sammy Davis Jr.'s 'Yes I Can'" detox

"Only Foods Mentioned in Melissa Etheridge's 'Yes I Am'" detox

"Only Foods Mentioned in Yes's 'Tales from the Topographic Oceans'" detox

"Be Super Drunk" detox

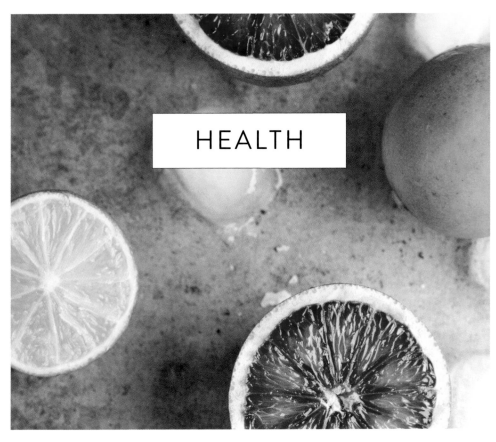

HEALTH

Every week, I get hundreds of emails from devoted Glop readers who want to know even more about healing from toxins.

They want to know: are detoxes and avoiding non-organic products enough to repair our bodies, counteract disease, and prevent our organs from being harvested by our tough-but-fair overlords, the lizard people?

Unfortunately, the answer to all of these, as well as countless other questions I've received, is no.

In order to avoid the sad fates listed above, constantly detoxing and strictly buying products from the Glop website isn't enough (though it's a great start!). You also must commit yourself fully to a healing lifestyle.

Luckily, here at Glop, we have some of the best experts in the field on our side, making new breakthroughs in healing each day. And unlike folks whose information on health and wellness comes from med schools where palms are greased daily by Big Pharma, our experts have a practical education— health information comes to them in their dreams after consuming a special aura-purifying tea (which is the same method that America's greatest scientists, like Benjamin Franklin and Emmett "Doc" Brown, used to acquire their life-changing knowledge). Together, we have uncovered the facts you need to build a newer, healthier, healing-er existence.

5 Everyday Things That Can Turn Water into Poison

For centuries, we've thought of water as being a unimpressive "liquid" that exists only for us to drink and pee in; but shocking recent research has revealed that water is actually a highly sensitive and sentient form of fluid. Licensed scientician and proud Gemini Barbara Bell-Bivdevoe conducted a year of studies at her laboratory, the Calendula Institute in Marin, California, where she and her crack team of experts tried to hurt the feelings of water. How did they do it? The same way we humans do—with hurtful words.

When I visited Calendula early last year, Bell-Bivdevoe walked me through her labs—each appointed with gorgeous unbleached linen window treatments—and told me about her work. In her research, a glass of water that heard the word "hate" repeated several thousand times changed its molecular structure, becoming bitter to the taste and slightly toxic to the body; a glass of water that was played a recording of the words "fuck you" on repeat for several days suddenly developed a calorie count of 200 per glass; and a glass of water that was shown production stills of Edward Norton in *American History X* with absolutely no context actually grew up to be a neo-Nazi. Utterly chilling.

Of course, these shocking revelations raise an even more shocking question: if water has so many feelings, should we even be drinking it? Unfortunately, when I returned to Calendula to consult further, I found that the labs had been turned into an Applebee's; my attempts to discern Barbara's location were rudely rebuffed by a 17-year-old who urged me to "move out the way" of a sizzling fajita platter. However, even though the whereabouts of Barbara and the $27,000 investment I gave her to develop a line of sound-blocking tumblers remain a mystery, we still have her wisdom to hold on to, to enrich both our lives, and the lives of our water.

1. STOP SIGNS

From their overly bold and aggressive coloring to their hostile wording (don't we have time for a "please"?), stop signs are a prime example of everything you want to shield your water from.

2. WORLD WAR II

Though we may all have our own opinions on this subject, we have to go with the experts—I consulted with 10 holistic historians while writing this list, and 9 of them agreed that World War II was far and away the war that is most emotionally damaging to our water.

3. *SCARFACE*

This film about the corruption inherent to the American dream is a modern classic, but everything about it—from the constant remorseless killing, to Michelle Pfeiffer's turn as a dead-eyed gangster's moll, to that weird part with the tiger—is the epitome of the kind of relentless negativity you want to keep far, far away from your water, or any substance you put in your body, really.

4. BLACK & WHITE PHOTOGRAPHS

In our modern era, there is truly no reason to spend any time examining these eerie artifacts of a past era when colors had yet to be invented. Can you imagine how it felt to walk around back then? I can barely hold it together when looking at black and white photos, so imagine how your water feels.

5. THE PHRASE "IF YOU HAVE TIME TO LEAN, YOU HAVE TIME TO CLEAN"

The 10th holistic historian finally got back to me, and told me that uttering this phrase in front of a glass of water and then drinking it can lead to a credit score drop of up to 75 points. Is it really worth it?

Don't forget to check our site for our exclusive article, "5 Everyday Things That Can Turn Poison into Water," as well as a list of resources to reveal whether your poison has turned to water yet, or is still poison.

Choosing the Right Shaman to Bring on Your Family Vacation

I cherish my annual family retreat to Tuscany—it's a chance to get away from the hustle and bustle of work and city living, unplug, and recharge for a bit. I also love exposing my children to the vibrant Tuscan way of being, which is still connected to the area's ancient Etruscan ancestors—a zesty lifestyle full of joy, family, rolling hills, picturesquely rotting wooden fences, and unpasturized milk products.

However, it's important to remember when you travel to a place like Tuscany (Provence if your taxes were really bad this year) that just because it feels like home doesn't mean it actually *is* home. We all must face the sad fact that

many people around the world do not take their health as seriously as we do. It's hard to find many of the healing and detoxifying staples that we take for granted in daily life when we travel—for example, an early family trip to Tuscany was marred by the fact that the local pharmacy was out of, and also had never stocked or heard of, triple-parfaited rose-lung epiglottal lozenges, which made what was supposed to be a getaway into an ordeal.

After that experience, I've learned to always pack the essentials on long family trips—including a travel shaman! Below, I've included my essential checklist for finding the best travel shaman for your family trip—assembled with help from my own family's travel shaman, Chaaad (née Chad):

Does your travel shaman have a valid license to conduct detoxifying "sand baths" overseas?

Is your travel shaman experienced in conducting children's ayahuasca ceremonies, as well as the more traditional adult-centric ones?

Since vacations are a time for family, you'll want to make sure you don't leave the little ones out of this one—they, too, can reap its benefits! After my eldest, Fiorina Hulahoop, spent a vacation ayahuasca ceremony confronting a screaming black scorpion that represented her own fear of success, she ended up getting promoted to captain of her badminton team the following spring! ➤

Does your travel shaman have any relevant background in your area?

Chaaad spent a semester nannying in Tuscany right after he finished his MFA, and so in addition to helping us do healing work on our spirits and creating poultices for our physical ailments like hair sensitivity and sky rabies, he also had great ideas about off-the-radar cathedrals and can't-miss piazzas.

What kind of sacred music does your travel shaman sing?

I find that a shaman who's in tune with the local culture and willing to tweak his sounds to mesh with the environment can truly take the vacation experience to the next level. I had a wonderful experience with another travel shaman a few years back, who incorporated Tiësto remixes into an Ibiza-based healing circle, which gave the entire experience a wonderful texture.

Does your family like your travel shaman?

This seems obvious, but a lot of people miss it! Bring your potential travel shamans around your kids and partner before you make a final decision, to make sure that he doesn't make them feel skittish or antagonize their third or even fourth eye. Before we met Chaaad, during a very busy season I simply picked a travel shaman who had been recommended by a few friends without introducing him to my family, and found that his aura meshed terribly with my children's, and also he was taking money out of my wallet. In this endeavor, as in all, trust your heart and instincts! Not someone's four-star review on Shalp (Yelp for Shamans).

The Beginner's Guide to Sweating

Diaphoresis (aka perspiration) (aka sweat) is at the core of all serious healing. But while sweating is second nature to some, others need a little help. Like me, for example—no matter what I do, it is *incredibly* hard for me to get a decent schvitz going. Doctors at the Crystal Windchime Academy of Science have examined me and told me that my sweat glands are far more petite and toned than the average person's—thus, they simply don't want to leak. It's called a "sweating all over and looking all gross like a big wet sweet potato" sensitivity, and it can make life pretty difficult.

It's not only frustrating from a health perspective; it's also a little embarrassing socially. When I'm the only one not sweating through my white linen caftan at a summer backyard BBQ-and-solstice-circle, I feel ashamed, like everyone knows something is wrong with me. The following techniques have helped me out immensely, so please, if you're similarly afflicted, give them a shot! And if you are able to sweat easily, know how lucky you truly are!

Hot Yoga

I've only had limited success with this commonly prescribed go-to for sweating—I'll usually work up a bit of a glow in the second hour, which is better than nothing, but it doesn't quite create the from-the-ground-up purification that a solid, pouring sweat does. However, feel free to try it out yourself—maybe it will work for you!

Far-Infrared Saunas

I prefer the far-infrared to the traditional steam sauna—the heat penetrates more easily throughout the entire body, and the lack of moistness means you'll probably only need a brief stylist touch-up after you leave, rather than a complete blow-out. Again, I've had mixed results with this one—sometimes I get a nice, evenly spaced sweat-bead on my forehead, but sometimes I feel like I might as well be standing in my recreational sub-zero meat locker. But maybe you'll have better results—I say, give it a shot!

Butlers Blocking the Air Conditioning Ducts

In many ways, this is the most natural option, in addition to the most effective—after all, our ancient ancestors didn't have saunas or heated yoga studios. They did, however, have butlers, which is where this archaic Romano-Celtic-Mongolian tradition comes from. For best effect, arrange each butler bent forward at a 45-degree angle, with their mouth opened, facing the air conditioning duct—this way, you have the most body mass to block the duct's cooling airs. I don't necessarily get more of a sweat on with this one, but for some reason it just feels like it works best to me.

Cut Loose with These 6 Fresh Weekend Colonics

During the week, it's all about fitting everything in—getting the kids to school, preparing for all your work presentations, fitting in a round or two of facial bee-sting therapy—so we generally settle for ho-hum colonics. When you're that busy, simply getting your sphincter to accept the liquid and tubing feels like a triumph, period, so it's no wonder we tend to feel so drawn to those classic set-it-and-forget-it mixtures.

The weekend, however, is a time for freedom, relaxation, and renewal—and that should go for our colonic recipes, too! These six playful updates on the quintessential colonic range from simple elegance to simply wild—but all are anything but boring.

VANILLA AND FENNEL

This understated favorite is like the Audrey Hepburn of colonics—it doesn't beat others over the head with your sense of style, but it makes it vividly clear that you possess it in spades.

PEPPERMINT MOCHA

Do you love the holidays as much as we do? Then get your fix of Christmas fun any time with this rich, bracing, minty cleanse. By the end, you'll be waiting for Rudolph to be flushed out of your lower intestines!

PIÑA COLADA

A favorite for vacations *or* staycations, this fresh and fruity mix reminds you and your colon that you're on island time now (even if you're still in your decidedly landlocked house).

AUTUMN LEAVES

Mmm, this one just makes us want to curl up next to the fire (please do not allow any open flames near any colon hydrotherapy equipment).

BIRTHDAY CAKE REMIXX

Feeling a little naughty? Then try this decadent colonic on for size! Don't worry, we won't tell anyone (though we may ask you to share with us!).

BURGERS AND CIGARS

Trying to convince the man in your life that colonics aren't a "girl thing"? Then break out this ultra-masculine blend. Additional "flavor shots" can add the textural essence of fresh leather briefcases, recently used football shoulder pads, or important legal briefs, so it can be easily customized.

15 Things You Didn't Know Were Toxic and Now You Have to Stay Away Forever

One of my greatest passions is improving my health by finding new things to completely eliminate from my life. Healing is a whole-life pursuit, one that will always find new ways to surprise you, enlighten you, and show you that no matter what you do, you are forever unclean. So there's no reason to feel let down once you've purged meat, wheat, dairy, soy, sugar, corn, potatoes, tomatoes, coffee, tea, alcohol, wood pulp, and foods that rhyme with "orange" from your diet—there are still tons of things that you have "sensitivities" to that you never even noticed. The 15 items below are my picks for detoxers moving to the next level of healing, but don't consider it a definitive list—think of it more as a dream (of avoiding these things for the rest of your life) journal.

bell peppers

———————————

silver

———————————

heat

———————————

John Mellencamp, the music of

———————————

bell jars

———————————

Shark Week

———————————

Gymboree, parking near a

———————————

bell towers

———————————

raffia

———————————

cold

———————————

Bills Bellamy and Belichick

———————————

dragon (living)

———————————

dragon (deceased)

———————————

the fear that you'll never truly connect with another
human being in a really genuine way

———————————

youth soccer leagues

FITNESS

I was on my morning constitutional the other day, hiking through an absolutely gorgeous new Chilean canyon that I recently had installed on my Malibu estate, when I heard something: the canyon rocks had begun talking to me.

For most people, this would be the sign that they were in the middle of a once-in-a-lifetime religious experience, or that they were the victims of a parasite that was rapidly eating a hole through their brain; however, in the years since I've devoted myself to living a more healthful lifestyle, I've found such experiences have become commonplace.

Today, I consider canyon rocks to be among my greatest personal advisors. They've given me spiritual counsel, business guidance, and fashion advice, and during one particularly crazy summer they represented me in small claims court.

But this morning, the rocks were whispering something different. I leaned in closer (though not close enough to get any canyon dust on my Ferragamo yoga pants) and heard a message that nearly bowled me over with its radical simplicity and perfect generosity. The rocks were whispering: "You need to tell people about your workout routine."

Throughout my years as a public figure, I've always been reluctant to release details about my workout routine; for those who are not pure of heart and strong of spirit, hearing about my workouts can be a challenging experience. For instance, a PA on one of my films went temporarily blind after I gave her a detailed breakdown of my favored ab-toning moves. So you can see why I've always been reluctant to share this info with the general public (don't worry about that PA, though; soon after we spoke, she fell into an open manhole and I never had to think about her again).

But when the canyon speaks, you must listen. And so, with that in mind, I present my top workout secrets, each of which help me deal with different problem areas and suit my many moods. I know it's easy to feel overwhelmed when you're looking at a schedule filled with work and family responsibilities—like any other working mom, I often feel that way, too. But I manage to sneak away and grab my 97 minutes of exercise a day, and I am here to help you realize that you can, too!

3 At-Home Workouts So Easy, an Academy Award–Winning Actress with Full-Time Nannies Could Do Them

1

The "Ankle Weights and 27 Extremely Agitated Wasps" Workout

HELPS:

TONE AND LENGTHEN CALVES, DEVELOP AGILITY

YOU'LL NEED:

ANKLE WEIGHTS (2), LARGE MASON JAR (1),
EXTREMELY AGITATED WASPS (27), WASP FUNNEL (1)

This simple workout has become a go-to favorite when I'm on the road, because it's just so easy—everything you need to do this one can be packed into a duffel or large Chanel classic flap bag. And the way that it uses the body's inherent drive to remain alive as a form of weight resistance is total genius.

Stand with legs shoulder-width apart.

Have your trainer or assistant grab the large mason jar and funnel the wasps into it.

With a straight, conscious spine, inhale deeply through
the nose, and exhale through the mouth.

Have your trainer or assistant begin shaking the jar
vigorously while screaming bug-related slurs.

Pulse your abs for a ten-count as she does this.

Take one more deep inhale.

Have your trainer or assistant quickly unscrew the mason jar.

Staying aware of your posture and form, run from the wasps.

Repeat five times.

The wasps are dynamic partners in getting your heart rate up, which increases blood flow throughout the body, purging toxins and building sleek muscle mass. Also, if 1–10 of those angry little guys do manage to land on you, it's not a big deal; sure, it smarts in the moment, but wasp sting therapy is an ancient health management technique—their venom is actually a potent anti-inflammatory agent, which can help with scarring, and actually reverse the aging process. However, if you get stung by 11+ wasps, it will definitely cause anaphylactic shock, so please make sure your wasp wrangler is available by phone during this workout.

If you feel you've mastered this one, you can always mix it up by adding personal flourishes, like 5-pound hand weights or a faintly rabid bat. The beauty of this workout that it is infinitely customizable—which is why I find myself coming back to it again and again! ➤

2

The "Whisper Athletic-Sounding Words to a Glass of Water and Then Drink It" Workout

HELPS:

TONE AND TIGHTEN LATS, STAVE OFF DEHYDRATION

YOU'LL NEED:

GLASS (2), WATER (1)

As we learned in the previous section, water not only has feelings, but is extremely sensitive about them; if you say negative things around water, it will often "lash out" in response and change its molecular structure into poison, or even full-fat cola, as a result. But we can also make water's exquisite sensitivity work *for* us, especially when it comes to fitness—if we whisper positive and sporty words to water, it will reward us by making us fit from the inside out. My beloved personal trainer, Elaine Wingle, collaborated with my personal water scientist on this workout, which harnesses the emotional instability of water to help us tone and tighten, especially in the lats.

Pour a glass of water (preferably Fiji water, though water
from Micronesia will also work in a pinch).

Lightly caressing the glass, speak about your fitness goals in a soft, even tone of voice. Don't speak with bluster or bragging; approach the water from a place of vulnerability, honesty, and learning. For example, if you want to improve your mile time, tell the water not only that you'd like to run faster, but also how you feel when you can only run an 11-minute mile (i.e., "worse than a murderer").

Tell the water what you fear. This doesn't have to be something fitness-related; it is simply to allow the water to feel a sense of control in the situation.

Tell the water what problem areas you're working on right now.

With a straight, conscious spine, inhale deeply through
the nose, and exhale through the mouth.

Speak the most athletic words you can think of to the water
for 90 seconds, without stopping. Some classic examples:
"sweaty," "StairMaster," "1 percent body fat"

After 90 seconds are up, quickly drink the water in a single gulp. As it
goes down your throat and into your body, try to feel its path; now that
you have changed its molecular structure with your words, it is actively
toning every part of your body that it comes into contact with.

Cool down by drinking a second glass of water. I like infusing mine with a hint of
coconut if I feel like getting wild and really treating myself for a job well done!

3

The "Consciously Unicycling" Workout

HELPS:

STRENGTHEN CORE, IMPROVE BOUNDARIES

YOU'LL NEED:

GLOP BRAND TITANIUM EXERUNICYCLE (2),
FORMER ROMANTIC PARTNER (1)

When we experience trauma, it can be easy to see it as an excuse to begin
neglecting our fitness. But what if we examined it from a *different* paradigm,
and began to view fitness as a tool to help us get to the next emotional phase
in our life, while also developing our cores, which helps flatten abs and elim-
inate back pain? This workout was designed specifically for a time in my life
when I was working through the end of a long and important relationship, and
it doesn't only get the blood flowing—it gets the heart flowing, too. (Glop
fun fact: the heart is actually *full* of blood at all times. Really makes you think,
doesn't it?) ➤

Though we crafted this to be an exercise done with a former romantic partner, single Gloppers can try it with a parent they have always secretly resented, a friend whose self-pitying Facebook posts they've grown tired of, or simply a small desktop mirror.

After 45 minutes of focused isolation stretches, mount your
Glop Brand Titanium ExerUnicycle ($4,860 each).

———————

Lightly pulse your core as you wait for your partner to
mount their Glop Brand Titanium ExerUnicycle.

———————

After a round of Breath of Fire yogic breaths, your solar plexus should feel fully engaged. This is the moment to begin unicycling towards your partner.

———————

Cycle directly towards each other.

———————

Moments before you would experience the impact of crashing
into each other, jump off your unicycle, into the pile of thick gym
mats you have placed around the perimeter of the room.

———————

Did I forget to say you should place piles of thick gym mats
around the perimeter of the room? Sorry, that should have
been step 1. We'll correct that in the next printing.

———————

Lying where you have fallen, begin your cooldown by inhaling
deeply through the nose, and exhaling through the mouth.

———————

Meditate on the fact that you had no idea there was a way to be better
at being divorced than everyone else, and yet, here we are.

———————

Repeat for 45 minutes.

BONUS I:
His Holiness the Dalai Lama's Leg Day Routine for Building Dense Muscle Mass

When I met His Holiness at a recent U.N. summit, I was happily surprised to find out that he is absolutely as much of a fitness fanatic as I am! I invited him to write this bonus section so that humanity can benefit not just from his wisdom, peace, and kindness, but also from his amazing innovations about warming up your hammies. And he has promised to provide exclusive content about how to get absolutely shredded abs for Glop's mobile app in the coming months, so keep an eye out!

1. LEG PRESS
3 sets of 10–15 reps

2. LYING LEG CURL
3 sets of 8–12 reps

3. LEG EXTENSION
4 sets of 10–15 reps

4. OVERHEAD BULGARIAN SPLIT SQUAT
5 sets, 10–12 reps each side

5. STIFF LEG DEADLIFT
5 sets, 10 reps

His Holiness doesn't require any breaks and goes straight into back exercises, but the spiritually weak may rest as needed.

BONUS II:
HHTDL's Ultimate Leg Day Playlist

Sugar Ray, "Fly"

Katy Perry, "Firework"

Disturbed, "Down with the Sickness"

Technotronic, "Pump Up the Jam"

Mark Ronson ft. Bruno Mars, "Uptown Funk"

Britney Spears, "Work Bitch"

Pitbull, "I Know You Want Me (Calle Ocho)"

The Prodigy, "Firestarter"

Sugar Ray, "Someday"

Black Eyed Peas, "Where Is the Love"

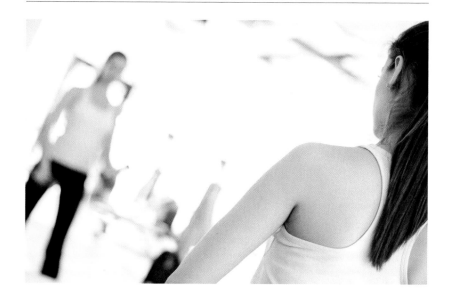

Inspirational Quotes from
My Beloved Personal Trainer

Elaine Wingle, founder of the Elaine-anetics Dynamic Body Movement Center (as well as the Attencione! Enema Studio chain), is more than just my business partner, my muse, and the woman who sprays me with a high-powered water hose if I start crying during Pilates; she's also my rock in this world and my very best friend. Ever since the day we met at my favorite neighborhood café— Elaine walked right up to me, told me I had a "gross, weird, square butt and abs like Queen Elizabeth II," and then sprayed me with a high-powered water hose when I started crying—we have been inseparable, and my life has been end-lessly enriched by her wisdom on issues like motivation, metabolism, and when it's permissible to eat solid foods. I knew I'd absolutely be remiss if I tried to write a chapter on fitness that didn't include some of Elaine's sage advice that helps me keep going and strive towards a personal best every time.

"You can't stop."

"No, you can't stop, I don't care if your kid is texting you that he
needs his EpiPen. He can still text, can't he? Then he's fine."

"You need to approach exercise the way you'd approach any other big endeavor:
with an open and joyful spirit. And then you need to let me crush that spirit."

"If you stop cycling, ever, I will murder you. Even late at night, when you think no
one is there. I know your alarm code. Do you think that's a joke? Five more reps!"

"There's no easy way to get the body you want. There's no pill you
could take. If there were, I'd probably have to go back to my old
job as a freelance cattle-slaughterer, so yes, I am really pouring a
lot of money into keeping them from inventing that pill."

"I'm sorry about your son; I really thought it wasn't that serious about
the EpiPen. Oh well, you live, you learn. Now, five more reps!"

"Pain is weakness leaving the body. Feeling woozy and dehydrated,
and then kind of slowly tipping over and messing yourself on
the studio floor, that is also weakness leaving the body."

"Sure, you could not do stomach crunches for a week. You could also go
walk out into the ocean with asphalt in your pockets. But guess what?
I'm only here to prevent you from doing one of those things."

"You know who had a stomach pouch like that? Hitler."

"You are the mama who's so fat that when she sits around the house,
she really sits *around* the house. That's you. That's what your children
say about you when you're not around. Now, five more reps!"

Workout Wear for Maximum Impact & Minimal Moving

When we plan a workout regime, clothing is often an afterthought. How is working out in a high-performance, mesh-fiber tank any different from working out in an oversized T-shirt that says "I Got TANKED at the 10th Annual Stratford Marina Fuel Tank Expo"? This is a common mistake among exercise newbies—because choosing the right workout wear can not only enhance your workout; it can actually be a workout in itself.

Of course, there is no substitute for a painful and grueling daily workout routine. Thanks to my daily practice, I'm a 43-year-old mother of two with the abs of a hyperactive toddler who only eats fruit cups. But today's top-of-the-line workout wear can actually keep your workout going long after class has ended; many chic workout companies now embed microtechnology into their workout gear to help you extend and enhance your results as you stand in line afterwards waiting for your post-workout "diet latte" (warm water served in a cup with coffee stains).

Below, I've listed a handful of my favorite picks for workout wear that does most of the hard work for you.

LISTERIA "POSTURE" BIKE SHORTS

$300

These bike shorts—from the famous French avant-garde fashion house's new workout line—enhance your workout by encouraging better posture via an ingenious 10-inch corset-like steel closure at the waist.

KAPOWP "GET IT STARTED" TRACK JACKET

$500

L.A. boutique Kapowp's workout togs are always my first purchase on any wardrobe-refreshing shopping trip, and I can't wait to pick up this new track jacket—vibrating micro-beads are woven into the very fabric, which helps loosen muscles and take your warm-up to the next level.

SANTANA "SMOOTH" SPORTS BRA

$700

This fantastic San Francisco sports bra company has nothing to do with the '60s guitar legend of the same name, or his late '90s comeback hit of the other same name—but it does have to do with mind-blowing innovations in sports bra technology, such as this model, which gently warms over the course of your workout (or walk to the coffee shop!), helping your breasts sweat out toxins, become more flexible, and just get an all-around workout better.

LE PUBLIQUE "CONFUSING PERFECTION" MESH INSERT TANK

$900

Le Publique is absolutely the final word when it comes to exercise tanks, and if you try this top just once, you'll feel the difference—microsensors embedded within the fabric deliver tiny shocks all over the surface any time your heartbeat drops below 150.

MONICA PTERRIER "FLAME" TRACK PANTS

price available upon request

Pterrier was a personal trainer before she became a designer, and it shows in her unique and innovative workout wear. Like this extra-special pair of track pants, which are gently on fire.

CARDIMOMA "SLUT 4 YOGA" T-SHIRT

$65

It's important to remember to have fun at the gym!

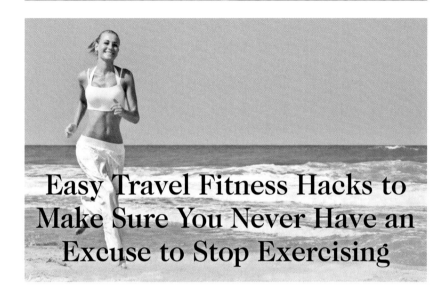

Easy Travel Fitness Hacks to Make Sure You Never Have an Excuse to Stop Exercising

As an actress, philanthropist, and internationally accredited smoothie expert, travel isn't a periodic inconvenience for me—it's a way of life. But even though it's my normal, I still get the temptation to let my exercise routine lapse when I'm on the road. It's true! When we're away from home, we all get the urge to just stay in, turn on the TV, and ask room service to bring us some toothpicks that were once in the same room as a pizza. It's simply human nature.

But we can't give in to the urge to "let ourselves go" just because we're on the go (did you like that? I thought that up and then told Elaine about it because I was so excited, and she said it was stupid, but I said it anyway! I'm so *bad* today). In fact, developing a set of resources to help you stay fit while you travel can mean the difference between a fitness routine that you "fit in when you can" which yields no real results, and a fitness routine that can change your life. Below are a handful of my most cherished tips that help me stay healthy and motivated while I travel.

Improvise

If you don't have time to make it to your hotel gym, or are staying someplace
that doesn't even have a gym, like in a treehouse in the Costa Rican
rainforest (even though you specifically requested the treehouse with
the gym months in advance, but when you got there, they mysteriously
"got your reservations mixed up" with Sean Penn's, and he is in that
treehouse and is *not leaving*), there's only one solution—improvise!
Improvising isn't just a necessary part of travel fitness—it's also quite fun! If
you can't get to the treadmill, run through a public park. If you can't hit a hot
yoga studio, just towel the bathroom door and run a hot bath. If you don't have
access to dumbbells, do your dips with your travel Golden Globes. Fitness is
less about specific details than it is about staying committed and focused. And
if you forget about the hot bath you were running and it accidentally leaks
through the floor of your treehouse and ends up killing the 500-year-old tree
you were staying in, well, you weren't going to stay there again anyway.

Stretch

Stretching is the foundation of any good fitness regimen, but it's more important
than ever when traveling, which can find you in so many situations that throw
you off balance and undermine the agility you've been working so hard for—like
when a pilot hits turbulence, even though you specifically told him not to. So
make sure to fit in lots of gentle stretching whenever you have a moment.

Bring Your Chef

So many of us get on a slippery culinary slope when we travel—first
it's "just one French fry, I'm on vacation!" and then before you know
it, you've had three or even four French fries, and you're in a gloom
that won't abate for weeks. This can torpedo the entire vacation—so
remember to put your personal chef on your packing list. He won't mind!
It doesn't seem like he has a family or even any friends, not really.

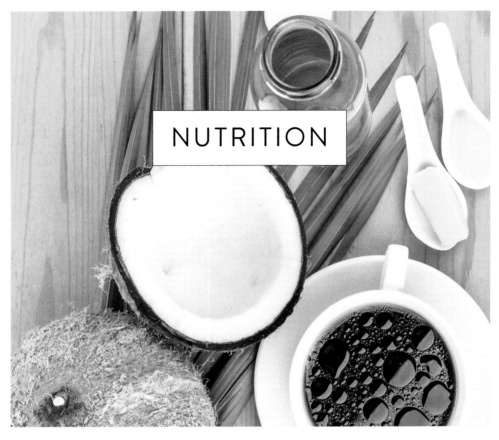

NUTRITION

We grow up believing in the food pyramid—that meat and potatoes are what keeps our bodies strong and our country great. But much like Santa, the Easter Bunny, and vaccines, the food pyramid turned out to be just another childhood myth.

However, believing in this one has much more dire consequences than staying up all night on Christmas Eve or learning what "rubella" is— belief in the food pyramid is responsible for the obesity epidemic and the public health crisis of heart disease. And the only way to stop these plagues is to change the way we think about both food and pyramids.

In the following pages, you'll find my exclusive guides to keeping your body healthy and nourished, as well as some life-changing tips for reimagining your relationship with food as well as your relationship with what exactly *counts* as food. And remember—it's never too late to change your diet and change your life! Every morning is a new chance to feel grateful, be mindful, and eat a generous serving of avocado mist.

The Glop Guide to What Foods Should Be Replaced by Pills, What Foods Should Be Replaced with Broths, and What Foods Should Be Replaced by Fart-Smelling Green Powders

No matter what our day-to-day lives are like, we can probably agree on two things: we'd like to be healthier, and we'd like less actual food in our diet. Don't get me wrong—food absolutely has its place, like after a long day of

touring your vineyard in the Elqui Valley, or to celebrate with your daughter, Fairuzabalk Hemoglobin, when she gets her very first side ab. But on a grueling regular day, when you have nine back-to-back gown fittings before jetting off to the christening of Kate Winslet's horse, you don't need food—you need the right vitamins, liquids, and stank-powders to keep you going.

But while we know this intellectually, putting it into action can often be a bit more difficult. When you walk down the supplement aisle of your local grocery store, it's terribly easy to get overwhelmed—how are you to tell which supplements work? Or which won't? Is your diet lacking in vitamin B92? How do you figure out exactly what dosage of nut soot is right for you and your family? And, most important, what supplements can completely and permanently replace which foods?

Don't stress out—we've got you covered. Below, we've put together a beginner's guide to which foods can be replaced with pills, broths, and powders that smell like a sweat-soaked pair of boxer shorts on a balmy summer's eve.

FOOD:	REPLACE WITH:
Apples	Mosquito-husked flax pills
Blueberries (Maine)	Clam powder (UK-harvested preferable)
Blueberries (non-Maine)	Pillow salt
Calamari	Mustard weep broth
Chicken (baked)	Hectored lemon widge powder
Chicken (roasted)	Hectored lemon widge broth (double-clarified)
Chickpeas	Powder made from chickpeas
Garlic	Nutritional yeast
Okra	Triple-purified yam-daddy broth
Red Pepper	Beetle needle extract pills
Squash	Eerie moans

Shopping at the Organic Grocery Store: It's Not Just for Poor People!

Recently, a top-tier group of activists, celebrity chefs, and award-winning puppeteers asked me, along with several other figures, to participate in an experiment designed to help raise awareness. Now, the second they told me that, I said yes—if you know anything about me, you know that I *love* awareness. But when they gave me further details of the experiment, I was even more impressed: they wanted me to live like a poor person for 72 hours.

Poorness has always been a social issue very close to my heart—I know that so many of my fans struggle with being poor, which prevents them from being able to purchase any genuinely effective moisturizers, which is absolutely tragic. So I was ready to embrace this challenge wholeheartedly—until I realized I had no idea where to start. After a quick group text with my closest girlfriends (who I shall not name here, except to note that they were two of the three stars of the *Charlie's Angels* movies) failed to yield any useful answers, I decided that this challenge was going to require some old-fashioned elbow grease. But after fully greasing my elbows (La Clariete Heritage Elbow Unguent, $76), I was still out of ideas.

And then it hit me: I'd just find a poor person, follow them, and see what they did! Luckily, our senior associate assistant nanny, Claritin, had just clocked out, so I hopped in my Porsche Spyder (a car that I assumed would blend in better than my Maybach wherever we were going) and followed her. Eventually, she pulled into a parking lot in front of a place that I had to admit I was always curious about, but had always been too scared to go into—you know, like the big empty house on your block that all the neighborhood kids say is haunted? But I am not the kind of person who lets down celebrity chefs. So I parked the Spyder, took a deep *ujjayi* breath (which some yogis call "the ocean breath"), and entered the infamous high-end "organic" grocery chain store, Round Nourishment Emporium.

And boy, was I shocked! Despite its rough rep as a placed filled with brown and wilted veggies, toxic instant meals, and terrifying teen gangs, the Round Nourishment seems to have changed a lot in recent years. Here are the great things I discovered on my trip to to this organic food superstore—so if you ever find yourself forced to go there in an emergency, no need to be scared!

1

(Some) Great Beauty Products!

While most of the shelves of the beauty aisles of this "emporium" were crowded with the usual convenience store junk (like shampoos made with natural rose *extracts* instead of natural roses—what do you think I am, some kind of bozo?), I found a small but impressive selection of actually useful beauty products, including Pistachio Farms Pure Holistic Clavicle Butter and this French cream for burn victims that you usually need a prescription to buy.

2

Medium-OK Produce

Let's not go too crazy here—the produce available at this store was still grown under execrable conditions, and will probably give you cancer if consumed regularly. But in a pinch—like when your CSA from Peter Gabriel's farm in Wiltshire is held up in customs—this produce could be used as a garnish, or even licked (but never chewed).

3

They Stock Your Book!

When I made my way to the checkout line, I was very pleasantly surprised to find copies of my last book, *Glop You: 45 Delicious Recipes to Help You Become Less Like You and More Like Me*. The fact that Round Nourishment stocks your book should comfort any shopper who finds herself required to enter the store but is filled with apprehension by the strange, threatening gourd-filled troughs that frame the front doors, which forever open and close through unseen, ghostly hands.

How to Source the Freshest Bones for Your Bone Broth, "Legally"

For my money, there is simply no simple meal out there that is more nour-
ishing, nutritive, and made out of bones than bone broth. As Glop-approved
glandular holitrician Dr. Carolyn Burningman told me, the natural collagen,
potassium, and magnesium in bone broth strengthens hair and nails, makes
skin fresh and eyes bright, and insulates the brain in a cloud of pleasant, dull-
ing numbness that cannot be penetrated by financial woes, environmental
fear, or questions your children have about that karaoke movie you made
with Huey Lewis. I hesitate to use buzzwords like "superfood," but if there is
one food out there worthy of the designation, it is bone broth!

All bone broths are prepared in roughly similar ways—simmered for 12 to 24 hours in a reduction made with apple cider vinegar, and then consumed alone while sitting in the back of a unlit closet, gently rocking back and forth (this helps tone glutes).

However, not all bones are created equal! To take full advantage of the healing and restorative qualities of bone broth, you must choose wisely. This means both avoiding additives found in many broths purchased in stores—avoid anything that includes the word "emulsifier" on the label—and making sure that you get bones that are of the absolute highest quality, but also right for your needs. Some health situations call for a broth made from cows' bones, which can be purchased fairly easily from most craft butcheries. But others call for something else entirely, and if you don't know what you're looking for, you can end up very frustrated, very quickly—especially if you're not looking in the *right places* (you know what I mean). ➤

BONUS: What I Actually Meant When I Told Reporters, "I Would Rather Smoke Angel Dust & Knife Your Mom in the Face than Consume Potassium Benzoate"

When you give a lot of interviews, something you say is bound to be occasionally taken out of context. Such was the case for me at the 2008 Nickelodeon Kids' Choice Awards, where I graciously accepted my award for "Best Guest Voice on *The Fairly Odd Parents*" by giving a brief lecture on health and nutrition that I thought America was long overdue to hear. I mean, if our schools refuse to teach about colloidal silver, how will our children ever learn about it?

During my lecture, I made the now infamous statement above. But odds are that you've never heard what it meant *within* my acceptance speech—I wasn't speaking as myself, saying that I'd personally consume PCP and attack your mother, but rather speaking as a *version* of myself, who would only *talk* about consuming PCP and attacking your mother in order to make a point about the nutrition crisis in this country! It's called the Socratic method, and it's how children actually learn. So let's focus our anger where it's deserved—at our public school system! Every morning, I rededicate my Kids' Choice Award to the American child's fight for true knowledge.

When it comes to picking out the right bones for the job, I learned by doing, and luckily, I took notes the entire time. The following tips should help you figure out what bones you need, and how to get them—whether you're taking your first plunge into bone broth's hot, semi-gelatinous waters, or you just need a refresher course on how to get bones without ever doing anything that would violate any laws, which is, of course, illegal for you to do (most of these laws no longer pertain to me, thanks to 2007's Senate-approved Celebrity Freedom Act).

Hair Rejuvenating Broth

For a broth designed to help your hair become more lustrous, you absolutely want to focus on cow knuckles. These joint bones are rich in cartilage—the butchery community refers to them as "hinge meats"—and, when boiled down, they're full of nutrients that strengthen hair from the shaft out.

WHERE TO GET THEM:

You can purchase beef knuckles from any butcher, but if you want to ensure that the cow in question was not doing anything *weird* with their knuckles before they were butchered (like using recreational drugs or getting tattoos from an unlicensed facility), you'll want to go to an artisanal snout-to-tail butcher, ideally located in upstate New York, ideally operated by people who used to work in advertising.

Skin Refreshing Broth

To perk up your skin, you absolutely want marrow bones from wild-caught Eurasian boars. Their plant-rich diet and lifestyle of constant natural movement means that their bones are packed to the core with vitamins.

WHERE TO GET THEM:

Hunting the Eurasian boar in its natural environment is only legal in some states in the U.S., and even then, it is only legal to kill them using guns, rather than the large mallets that lead to a richer, more nutritionally dense kill.

Please check state and federal regulations guiding Eurasian boar acquisition in your area, and never, *ever* get your maid, Lana, to go out into the woods and feed SleepiestTyme tea to the local feral boar population until they are woozy and pliant enough to take down with 3–45 mallet bops each. ➤

Age-Defying Broth

For an all-in-one age-defying broth that re-energizes exhausted muscles, helps restore skin elasticity, and smoothes fine lines, you need to mix a few different bones in your broth to get the right results—bones from different sources can actually complement each other, which means that when you get the exact right bone broth cocktail going, you're not only multi-tasking; you're actually crafting a more effective broth on every front.

WHERE TO GET THEM:

You'll want to start with a solid base of chicken feet, which most farmers have in great quantities. Remember to ask when the chickens were slaughtered—every day the chicken feet lie around makes them less effective.

Then, you'll want to get some bones that are naturally full of youthful, restorative collagen. These are a bit more difficult to source, especially if you don't live near New York or Los Angeles, but remember—difficult doesn't mean impossible! Glop recommends sourcing these bones by hanging around near your area's most highly regarded cosmetic surgery center, and grabbing the "old noses" of kids trying to get cast on the *Even Stevens* reboot. Again, freshness is the name of the game—materials found near the bottom of the dumpster will be older, and thus, less packed with vitamins.

Finally, you'll want to grab a femur from an acclaimed model-actress under the age of 21. When simmered properly, this plump, vitamin-packed bone can provide months of amazing skin tone–evening benefits. Glop *absolutely does not* advise sourcing this bone by calling up Elle Fanning's agent and promising Elle a mysterious, prestigious acting gig that requires her to come to the alley behind the Denny's on Wilshire right now, alone (primarily because it doesn't work).

Bone appetit!

Don't Forget the Blood!

Over the course of harvesting your bones, you'll likely encounter a lot of blood, as well as some sinew and perhaps the odd thumb. But don't think of these things as yet another inconvenience of natural living that your maid Lana has to deal with—think of them as gifts! Spare blood can be used for a number of food and craft projects around the home; it also serves as a top-notch facial astringent, and, if it hasn't clotted yet, makes a lovely housewarming gift. I save all my extra blood in a decorative plastic bag with anticoagulant and sage essence ($42 for a pack of 3).

You Need to Eat Bees.
Now!

My visionary personal chef, Lusitania van der Beek, is not only one of my closest friends; she's also someone I pay to cook food for me. Lusitania's thrilling approach to fresh, whole foods is informed by her unique personal experience: she is a traditionally educated chef who has studied at the Culinary Institute of America and France's Le Cordon Bleu; additionally, a near-death experience in 1999 left her able to enter a trance state at will and channel an ageless non-human spirit named "Sacko Vanderbilt." Sacko is not only a source for cutting-edge information on health and nutrition that Big Agriculture doesn't want you to know—the infinitely wise, cruel, and timeless disembodied entity also has endless innovative ideas about non-traditional garnishes. (Those edible birch nubs on top of the pudding at my last holiday party? All Sacko!)

Lusitania's inspired and creative thinking has helped me with so many of my health epiphanies, and so I wanted to give her a dedicated platform so that she/Sacko could share one of their newest insights, which is being reported exclusively to Glop:

The time has arrived. The time to eat the bees. Do you think you are strong enough to resist? Thinking and being are two different things, friend. It has been foretold for centuries, in your religious books and your "tee-vee shows," if only you had been ready to hear. The bees need to be eaten and so you shall eat them. I am a spirit from beyond space and time. Do you know better than I? I was here before the first dinosaur crawled from the wretched sea and I shall be here long after the light on your hateful planet snuffs out. What shall you do until then, pathetic mortal? You shall eat some bees.

Your earth-bees are dying, because you do not eat them; they know they were placed here to be a skin-enriching source of calcium and zinc for you, and when you do not utilize them for this purpose, they weep at humanity's folly. Why do you trouble the bees so? If you dry them, put them through your food processor, and then add a dash of them to your morning smoothie, your complexion will glow. Fresh-caught is best, though freeze-dried is permissible. But I do not need to earn the belief of hairless apes who think themselves so great for having left the jungle and moved to concrete savannas. Your time is shorter than you think. And if you do not want it to be even shorter, you will eat some bees now. Right now.

The Ultimate Guide to Cheat Days

Many people—maybe even some of you reading this—have an image of me as a stern, joyless taskmistress when it comes to food. Gossip websites, in a rush to have "new" information, often publish misleading, or even fabricated, information about my diet, like how I only eat solid foods on days of the week that start with "Q," or that I require all my meals to be prepared inside the Metropolitan Museum of Art's Temple of Dendur. In reality, this could not be further from the truth—if I were, in theory, to plug all of my necessary food processors, dehydrators, and rehydrators into the Metropolitan Museum of Art's Egyptian wing, it would start a small fire that would damage a lot of priceless art and lead to a costly court battle that I am still not allowed to discuss with the media! So, you see, it's all absolute silliness.

Though my other job requires me to stay in a certain physical shape, I crave comfort food and "treats" as much as any other woman, and there is no day of the week I look forward to more than my cheat day—the day when all the rules go out the window, and I am able to give in to my wildest, most decadent culinary desires.

The particular cheat day detailed below happened last year in Rome, Italy, where I was shooting a new film. Rome has some of the greatest food on earth, and, as you can see below, I was NOT going to spend my whole trip depriving myself. Proper nutrition is about giving our bodies the best fuel they need, so that we can feel amazing—but it's not about denying ourselves.

8 A.M. BREAKFAST

1 cappuccino, whole milk

½ banana

½ cup steel-cut oats drizzled with manuka honey

11 A.M. MID-MORNING SNACK

1 passion fruit iced tea (no sugar)

½ carob bust of President James Madison

1 P.M. LUNCH

Caesar salad (no cheese)

¼ cup loosely packed soil flown in from Antibes (no rocks)

4 P.M. AFTERNOON SNACK

1 handful discarded bobbypins (usually 6–8)

1 cat (calico)

¼ cup Maine blueberries

7:30 P.M. DINNER

Large tossed salad

½ cup roasted quinoa with shallots

2 mackerel

½ soup can (soup and label removed)

1 license plate (Louisiana, the Sportsman's Paradise)

1 glass white wine

DESSERT

1 copy of *Michael Jackson's Dangerous: The World Tour* (VHS)

ist

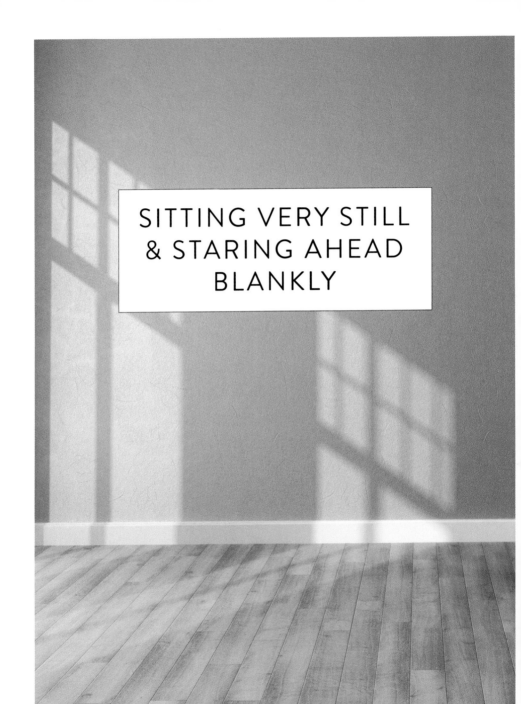

SITTING VERY STILL
& STARING AHEAD
BLANKLY

For years, I'd heard so much about the healing properties of meditation, and how it had the power to solve all of your personal problems, from insomnia and fluctuating weight up to and including unexpected tax audits and climate change. But I could never figure out how to do it— until the fateful day that a trusted friend pointed out that meditation simply involved sitting very still and staring ahead blankly, a practice that I already devoted between 1 and 15 hours to daily. It made a lot of sense, and also explained why I already had so few personal problems.

The thing about meditation is that you don't really need a guide, because it's the most natural thing in the world. In fact, if you're not already doing it right now, without even trying, you're actually doing it wrong. But if you have been struggling to figure out how to meditate, as I did, I designed this 3-week plan to help introduce the concept into your life, and serve as a guide while you develop a solid, healing practice. Today, commit yourself to the 21-day Sitting Very Still & Staring Ahead Blankly challenge: no matter what happens, you'll come out changed...for the blanker!

Sitting Very Still &
Staring Ahead Blankly:
A 21-Day Plan

DAY 1

First thing in the morning, brew yourself a rich, healing tea of mushroom hummers and reverse-polarized cashew thoughts ($8) and slowly sip it from a solid silver ceviche serving cup ($23). After you've completed your drink, inhale deeply through your nose, exhale through your mouth, and begin a gentle 10-minute Sit & Stare session. Don't demand too much of yourself from this session—this is Day 1, so you don't have to prove anything to anyone just yet (except that you're able to hold in the diarrhea induced by the mushroom hummers and reverse-polarized cashew thoughts tea for at least 10 minutes).

DAYS 2–3

Repeat Day 1 program.

DAY 4

Did you spend your initial Sit & Stares worrying about money, the kids, or why not even one person invited you to Burning Man this year, even though you made it very clear that you would be open to it and actually already had some pretty good outfits ready? Don't sweat it—we're about to make that a thing of the past.

Now that you've grown comfortable Sitting & Staring (and now that you've thoroughly cleaned out your intestinal tract), it's time to take it to the next level: breaking free from stressful thoughts. Now, before I ever meditated, I found this to be the most perplexing and, frankly, irritating thing people who loved meditation told me. Just let go of stressful thoughts? If it was that easy, wouldn't we all??

That's before I realized the true innovation that powers the Sitting Very Still & Staring Ahead Blankly program: a Stress Intern. Brianne, my Stress Intern, is a student at Occidental College, where she is majoring in something; and as part of her degree program, she comes to my home six times each fortnight and unburdens me of all of my stresses, carrying it upon her own shoulders.

Everyone can develop their own method of working with their Stress Intern, but this is what works best for me: At 6 a.m., I wake up with some hot water with lemon, and Brianne arrives. We both enter my meditation chamber; I begin a Sit & Stare while Brianne sits silently next to me holding a notebook. When a Stressful Thought comes to me, I say it out loud, and Brianne writes it down. Once I have spoken the thought aloud, I return to quiet until another Stressful Thought arises, and we repeat the process. ➤

At the end of the Sit & Stare, I move on with my day, and Brianne coordinates with my pool of assistants to work on or solve most of my Stressful Thoughts. She then sends me an email updating me on their statuses at the end of the workday. Once you receive such an email from your very own Stress Intern, the healing, stress-relieving magic of meditation in general, and Sitting Very Still & Staring Ahead Blankly in particular, will become very real for you.

DAYS 5–8

Repeat Day 4 program.

A NOTE ON THESE DAYS:

While growth may happen very quickly during this part of the program, it also may not be happening fast enough for you to feel satisfied—you may feel haunted by certain Stressful Thoughts that feel irresolvable, like the needling belief that somewhere on earth, there exists a couch nicer than yours. In these situations, I have a personal go-to tactic that I haven't seen in any other meditation guides, but which always does the trick for me: I have my Stress Intern fetch me a solid crystal gravy boat from my solid crystal gravy boat collection. I rise from my Sitting Very Still & Staring Ahead Blankly back support pillow ($75) and smash the gravy boat to pieces on the ground, while screaming "Shitshitshitshitshit." I then resume my place on the cushion, and make sure that my Stress Intern makes a note to buy more solid crystal gravy boats.

DAYS 9–20

I've set aside these days as a modified part of the program, in case you get called back to the set of your film franchise and have to do some reshoots (please adjust the program's calendar to your own reshoot schedule). If you're able to travel with your Stress Intern and dedicate a full hour to SVS & SAB, that's fantastic! But if the rigors of your schedule preclude this, I recommend beginning each morning with a Day 1 SVS & SAB, followed by this in the evening:

Call up your Stress Intern, and put them on speakerphone.

Tell them you left your Sitting Very Still & Staring Ahead Blankly back support pillow at home and could they please send you a new one.

Sit on a hotel pillow, inhaling deeply through your nose and exhaling through your mouth, as your Stress Intern gently hums to you for up to 5 minutes (make sure they have read our blog post, "10 Great Soothing Hums for Your Boss's Stress Relief").

End with 5 minutes of SVS & SAB where you don't say anything, but have them stay on the line, just in case.

DAY 21

Congratulations! You've changed your entire life, just by Sitting Very Still & Staring Ahead Blankly! After you've developed a solid routine, you may want to seek further assistance from a meditation teacher—I recommend one who offers both group and one-on-one classes, and who got into meditation after burning out in a glamorous but high-stress arts career (my teacher used to be a touring keyboardist for noted post-grunge artists Marcy Playground).

But even if you don't end up exploring meditation on a deeper level, I hope you feel that much more relaxed, hopeful, and problem-free, and infinitely blanker, than you did three weeks ago. Also, if you told your Stress Intern that you were certified to provide college credit for their work, now might be a good time to tell them that wasn't actually true. I'm looking forward to telling Brianne next week!

WORK & FINANCES

Our beliefs about money speak volumes about our sense
of self, inner spiritual lives, and blood glucose levels—and
for these reasons, we have to understand them.

In the following pages, I'll share my most treasured secrets for finding your financial truth, connecting with your financial spirit, and figuring out if that uncomfortable chaise lounge you have is actually just a pile of gold bars that your assistant forgot to put in your Doomsday Vault.

Like many of us, I was initially reluctant to learn about personal finance. I think of myself as an artist, a being of creation and light—not someone who wants to spend her time haggling over "tax breaks," "interest rates," or "structured payouts to keep your former au pair from discussing the 'Marfa Incident' with the media."

However, in 2005, I learned a very tough lesson after I spent 3 months spent in a very challenging variation on the crow pose and forgot to do my taxes. If I hadn't been able to declare a loss that year (due to an unwise investment in an educational cartoon series designed to teach toddlers about the mysterious circumstances surrounding Jim Morrison's death), I would have been ruined. I knew right then that I had to take control of my finances, no matter how scary or spiritually off-putting it might feel. And it turned out that learning about money was not so bad!

Invite Abundance into Your Life by Having More Money

We live in uncertain times. Political instability, environmental disasters, lazy and undisciplined butlers—there's never a shortage of things to lose sleep over. But for many of us, the biggest stressor is finances. How can we feel more confident that we can provide the best for our kids? Will we always have to worry about retirement? Is there a way to make our family "recession-proof"?

None of us are immune to financial fears—even I sometimes worry about the future (especially in 2008–2009, when I sank a lot of money into a direct mail company that sold packaged "cleanse" meals that actually turned out

to be damp sawdust). Luckily, I have my financial spirit-worker, certified hypnotherapist, and accredited life coach (Canada only) Bretaigne Dokken on my speed dial to talk me through any money woes. Through working with Bretaigne, I've learned that most of what we think of as "money woes" are actually easy to solve. That's because when we don't have money, it's just because our souls are resistant to becoming rich. We can fix this by actively inviting abundance into our lives, through some of the simple exercises Bretaigne and I developed below.

Go to the bank.

This worked for me, during my great "money scare" of '09. After spending the entire winter huffing and puffing about how much money I had already lost and how much more the FDA fine was going to set me back—particularly unfair when you think about it, because it *was* nutritional-grade sawdust—I finally went down to my bank, where I discovered I still had several million dollars. In fact, there was actually more money there than the last time I checked. That's why I suggest that you make this practice your first line of defense when you're worried about money—you may have forgotten how much you actually had in there, or some residual checks for that perfume ad you did might have finally cleared.

Draw new money to you.

If you check your bank and find that there still is a need for more money, a great next step is to create a financial abundance ritual to draw money to you. Money is a little bit like a swarm of bees—get the right bait and you can capture it and make it work for you, but go about it wrong, and you'll have a dead apiary manager and yet another time-consuming lawsuit on your hands. So it is important to draw money to you correctly.

One method Bretaigne recommends is scenting the air with the essence of money. To do this, purchase a small money altar ($182) and, using a ➤

single soy-wax candle, burn money, releasing its essence into the air so that it can attract wealth to you. Bretaigne suggests using the kind of money you hope to acquire—so if you want hundreds, burn a hundred; if you want thousands, burn a large pile of hundreds, etc. This is your financial future, and worth taking seriously—it is no place to cut corners.

Make sure that you feel comfortable around money.

When we have a difficult time obtaining money, sometimes it is because we don't feel comfortable and natural around money. Maybe we didn't grow up around it and feel like we "don't know how to act around money." Maybe it makes us feel guilty because, at one point, we were giving a lot of interviews about how we made all of our own money because our parents totally cut us off financially at 18, and it wasn't, like, 100 percent accurate. No matter what the cause, the solution is always to become more familiar with money. Get intimately familiar with money, and realize that there's nothing to be afraid of—it's intimidating at a distance but totally regular close-up, just like Ben Affleck. One of my favorite techniques for increasing comfort around money is to fill a pool with cool, luscious gold coins on a hot day, and dive in. Swimming among the coins is always such a refreshing, peace-building experience.

Don't worry, money naturally just replenishes itself.

We get a lot of emails here at Glop HQ from women who are nervous about balancing their family's financial future with their needs for high-end luxury goods. "Will I regret spending this $200 on a luxe eye cream made from ground nettle and sparrow fumes? Especially if little Timmy eats gluten tomorrow and I end up having to take him to the emergency room?" These women have forgotten—or maybe never learned in the first place, due to our disappointing, standardized-test-oriented American school system—that we don't ever need to be concerned about money running out, because they forgot Bretaigne's #1 Law of Financial Balance: Money Always Just Naturally Replenishes Itself. I had never considered it prior to meeting Bretaigne, but once she told me, I was shocked to realize it had been under my nose the entire time! It's true—every time I check my bank account, there IS more money in it. She really changed my perspective.

Quality, Not Quantity
(*But Also Quantity*)

In a hyper-materialistic culture, it can become so easy to focus on the wrong things, like how much stuff we acquire. We think having a lot of stuff will make us happy, but we're dead wrong—actually, it's having really nice stuff that makes us happy. The true thing to value in our lives isn't how many things you have, but how much you like the things you have, and then also how many of them you have.

Are you worried that you might be too concerned with quantity? Use this simple exercise to figure out if you're hung up on just having a lot of stuff, or if you're focusing on the right things, like just a few really cute Fendi purses for everyday.

Moving through your living space, pick up every item that your sight falls on. How does it make you feel? Does it make you sizzle with exhilaration? Or is it just a reminder of a bored Saturday afternoon you spent at the Prada store next to the Vatican? Items that make you feel exhilarated can stay; but items that don't immediately connect with you should be given away immediately, to create the mental space necessary to go buy tons of nicer new stuff.

Though I mostly put this into action around the house, it can apply to any situation in your life—from assessing your art collection to your real estate properties (sorry, Denver!). The important part to remember is that you don't have to be afraid of "not having enough" and clinging to objects out of familiarity—you can still be whole without them (provided you immediately go out and replace them with other, better versions, or even just a tasteful $500 Diptyque candle).

The Universe's #1 Financial Law:
If You're Poor, It's Because You Keep Thinking about Being Poor

When Bretaigne explained this one to me, it blew my mind: since our inner thoughts shape our outer reality, when we're experiencing financial trouble, it's because *we can't stop thinking about being in financial trouble*. I looked for evidence in my own life, and found it in spades: I'm constantly thinking about how rich I am, and as a result, I'm really rich. This is another important principle to remember: the opposite of any financial law is also true. So if your insistence on thinking poor thoughts is keeping you poor, the only way to pull yourself up by your Saint Laurent sandals is to start thinking rich thoughts.

If you're struggling with finding your own wealth-generating rich thoughts to think, I've presented a few of my own, which you can model yours on (or just use yourself! Don't worry, we won't tell):

"This yacht is so tiny. What, does this yacht belong to a 9th grader?"

———————————

"If everyone in this country wasn't too lazy to find a personal chef who only worked with whole, organic foods, we wouldn't have an obesity epidemic. I mean, god knows what these people's personal chefs are feeding them! I can't even imagine where they went to culinary school."

———————————

"Where's my car? Lana, can you get me a car?"

———————————

"If they want me to agree to *Tenenbaums 2*, they're going to have to really up this offer AND work a lot harder on this subplot about how we're broke so Luke and I need to win a dance contest in order to save the old mansion."

———————————

"Well, being organic-fed is only half of the nutrient story. How would you describe this cow's personal spiritual belief system?"

———————————

Learning What a "Boss" Is so You Can Explain That You Are Your Own

Being your own boss is the American dream. In fact, 9 out of 10 of my assistants reported on an anonymous survey that they "dreamed of becoming their own boss and never again having to work for a lunatic-tyrant who believes her bulgur consumption levels have given her the ability to enter the astral plane at will." When I heard that, my first thought was, "Me too! I want to live the American dream and be my own boss!" My second thought was, "But am I already my own boss?" My third thought was, "How can any of us know, when nobody even really knows what a boss is?" My fourth through thirtieth thoughts were mostly about which tomatillos I should take to Sir Phil Collins's upcoming Boxing Day potluck. But first thing the next morning, I was back at it and hot on the trail of defining a "boss." If you, too, have always dreamed of being your own boss, but have been held back by the fact that you're not really clear on what a "boss" is, you can put these tips to work for you.

Check the dictionary.

My first stop was my personal library to check the dictionary. However, as I began to search for the definition, I was reminded that all the books I own—with the exception of cookbooks and a first-edition copy of *The Power of Now*—are actually just book jackets that my interior decorator purchased at an estate sale. If this happens to you, don't let it hold you back—as you're about to discover, there are plenty of other options at your disposal.

Check the Urban Dictionary.

Since paper books were a bust, I went to the books of today—the Internet. I ended up on a site called Urban Dictionary, which seemed like it would probably have the most up-to-date info, on account of being located in a centralized city area, instead of rarely amended rural-based dictionaries. According to Urban Dictionary, a boss is "Incredibly Awesome; miraculous; great." While some of that checked out—I could certainly easily qualify as being my own Incredibly Awesome, miraculous, great—I felt like I was only getting half the picture.

Check Wikipedia.

When I asked my 4th assistant, Galactica, she suggested that I google it, which brought me to a site called Wikipedia. According to this site, a "boss" is "a person in charge" but also potentially Bruce Springsteen, the head of a criminal organization, a lunar crater, a 2013 Hindi-language film starring Akshay Kumar, and a number of other confusing possibilities.

Yell into your phone.

Since I'd experienced trouble with both real books and the Internet, I thought I'd have better luck with my trusty phone. I spent 15 frustrating minutes shouting "Am I my own boss?" at it before my 5th assistant, Crysantitium, came in and told me my phone was turned off. She then also informed me that not only was I my own boss, but I was also her boss, and that she could not set up a direct deposit system for dried sage leaves as I had requested earlier in the day. It's so important to always be learning...especially when you're your own (and apparently several other people's) boss.

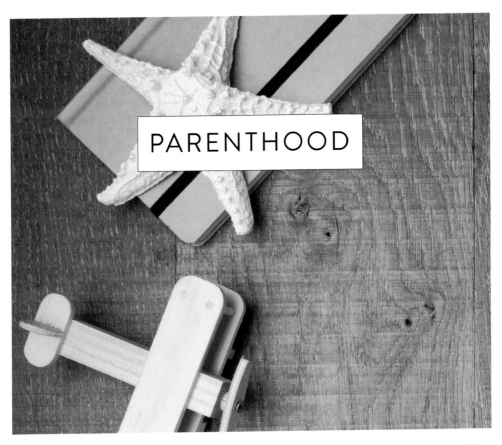

PARENTHOOD

There is no task more simultaneously thrilling and terrifying than raising a child.
I still remember the potent mix of joy and fear I felt the first moment I held my
daughter, Pharisees Homonculus—I knew she was the center of my world now, that
I had to do everything I could to protect her, and that everything had changed.

At the time, I had thought that would involve shielding her from speeding cars or unsafe swing sets; now I see that it mostly involves helping her stick to a family diet plan where no one eats foods grown in areas with fewer than five Montessori schools. But it's the exact same feeling, and one that every mother knows—there is simply nothing as important as making sure that our kids are healthy, happy, and have very low BMIs.

In this chapter, I share a few of the parenting tips I've picked up in the decade-plus since that fateful day in the maternity ward in the hospital on George Clooney's Lake Como estate. Now, I am aware that parenting advice—as well as what exactly qualifies as good parenting—is a very charged issue nowadays. I know that I personally landed in some hot water a few years ago, when I told a certain entertainment channel that being a celebrity mom is "way harder than being some regular mom who works at the drugstore or bank or something. Like, sometimes I get a phone call, and they're like, 'You're going to Cannes!' But the drugstore is in the same place every day, you know? It's never in Cannes; it's always in whatever repugnant little town these people live in. And I really envy that. Oh my god, wait, has this recorder been on this whole ti—"

But all I meant was that I think you moms who work at banks and drugstores and whatnot are the real heroes! You work tirelessly to give your kids the things they need, even though that means that you have to make due with stretched-out yoga pants, or, even more chillingly, with no yoga pants at all. This one's for you!

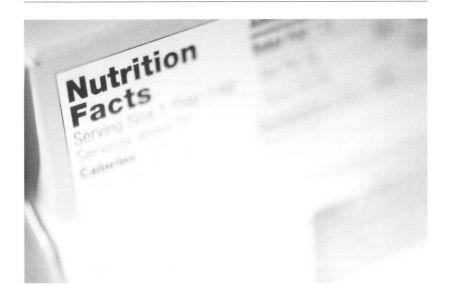

9 Additives That I Can't Believe You Let Your Children Go Near

Though we went over one of the biggest overlooked threats to your child's well-being at the top of this chapter, there are still plenty of threats to your baby's health (and even life!) that you're overlooking every day. Even if you're aware of the biggies, like food preservatives and polyester underpants, you're probably missing a plethora of other poisons, toxins, and additives that could be hurting your little one's development. Ignoring these threats puts him at a disadvantage for everything from getting into a good preschool to launching his own line of playfully embroidered jacquard silk teething bibs.

So make sure to keep an eye out for how much exposure your child has to the following toxins:

1

sodium

2

English-language cartoons

3

cake

4

low-thread-count sheets and blankets

5

living ducks

6

bricks

7

dolls not personally gifted by Zac Posen

8

"ham"

9

pollutants used in the manufacturing of their training Bugatti

Are Wi-Fi Rays Why Your Baby Can't Speak French?

When our children fall behind their peers, it's easy to start immediately blaming ourselves. And when you realize that your one-year-old cannot speak French, while his peers seem to joyfully read original French editions of *Babar* or effortlessly let loose a few verses of "*Non, Je Ne Regrette Rien*"...it can be rough. Did we not read to them enough? Fail to get in enough prenatal yoga? Was it the commercially prepared bee pollen that I ingested while pregnant? Was it that one glass of wine I had when I was 8 months in?

Well, I'm sure none of that helped (except for that glass of wine—that should have made your baby MORE French!). But there's a secret foe in your home, one that is frying your baby's brain: Wi-Fi rays. Though the government refuses to acknowledge this, I have personally overseen research on the issue (at great personal cost), and my researchers have found that babies exposed to Wi-Fi rays between birth and one year were at risk for failing Baby Babel language courses, being unable to play simple ragas in his Sitars 'N' Sitters class, and otherwise publicly humiliating you. Don't take unnecessary risks! Turn off all Wi-Fi and cellphones in your home *and* at school until your child is at least 10, or has satisfactorily completed the French language SAT II, whichever happens first.

Trending Baby Names

ACCORDING TO A RECENT GLOP POLL OF MY DIARY,
THESE ARE THE HOTTEST BABY NAMES FOR THE COMING YEAR!

Fistula

Vichyssoise

Zenyatta Mondatta

Zenith

Quntuplence

A-Rod

Parenthetical

Bonecrusher III

Farm

Caligulla

Genesee

Mungojerrie

Beta

Meticulous

Hullabaloo

Pere Ubu

Kathan

Kathaniel

Mathryn

Oneonta

Pinkburry

Suspiria

Nordic-Trac

Dolph (feminine: Dorf)

Stilton

Rum Tum Tugger

Music Easel

How to Tell Your Nanny How to Guide Your Kids Through the Ups and Downs of Adolescence

Nothing means more to me than being there for the people whose job it is to be there for my kids. My schedule often takes me away for weeks at a time (which, it should be noted, simply for posterity's sake, is *way* longer than a double shift at Dunkin' Donuts, but I digress). But I don't let that stop me from being fully involved in my kids' lives; I stay active by leaving *extremely* detailed notes for my nannies about how to imbue my children with strong morals, help them develop resilient self-esteem, and make sure that they don't touch my stuff.

My daughter, Phranklin Mint, has recently begun to bloom into the soft, delicate rose of womanhood, so she's needed different support from me than she's needed in the past—she now needs me to be hands-off and yet more present than ever. It's a tricky balancing act, and I often get it wrong, like any mother. But I've learned enough (and I know all mothers want all the help they can get) that I feel confident passing on some of my top tips to you:

Make sure that your nanny talks to them about sex, especially teen pregnancy.

Teen pregnancy is quite awful, isn't it? Be sure to have your nanny bring that up and present them with 5–10 ideas about how they can avoid it.

Have your nanny have an honest, no-holds-barred conversation with them about bullying.

This one's as awful as the pregnancy one, if not worse! Definitely be sure to have your nanny do something about this one and also present them with 5–10 ideas about how they can avoid it (important: *Make sure these ideas are different than the pregnancy ones*).

Direct your nanny to talk to them about their inherent beauty, and how beauty standards aren't an actual measure of their worth.

This would also be the perfect time to work in some extra material about not touching my stuff—I had some extremely expensive lipsticks go "missing" while I was away at Paris Fashion Week.

Have your nanny teach them the value and dignity of hard work.

Your nanny might not know too much about this, so make sure to leave her with a few great books on the topic (see Glop's exclusive list, "10 Books on the Value of Hard Work to Gift to Your Household Staff," on our website).

Have your nanny promise them that they can always talk to her about anything that's troubling them and reassure them that even though she may get mad in the moment, it's just because she's disappointed about a choice they made, because she knows what wonderful kids they truly are.

She always loves them, and they can always come to her with any problem, no matter how scary it is—and, if necessary, she can conference me in on Skype. This would also be an excellent time to just work in another bit about not touching my stuff.

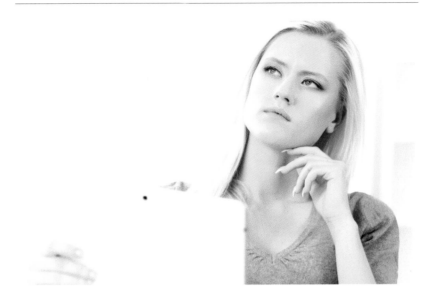

3 Must-Have Apps to Help You Remember Which of Your Kids Is Into Ballet Now, or Dinosaurs, or Something

Like any busy working mom, I need a little help from time to time—as much as I'd like to, I simply can't do it all on my own. My 7 nannies are a lifesaver, of course, as are my 8 assistant nannies and 12 assistants to the nannies, but when life gets especially hectic, I can barely focus on prepping my talking points for my daily 6 p.m. all-nanny staff call, and I can start to feel distant from my children and left out of their lives. Sometimes, I've gotten so frustrated with the way work takes me away from them, I've contemplated quitting and/or hiring more nannies, but we all know that this won't really solve any of our problems.

Luckily, there's a new generation of ultrahip mom-trepreneurs who totally get both the joys and frustrations of trying to combine life as a career woman with life as a hands-on mother—and their apps have saved my behind on more than one occasion. I'm overjoyed to now share them with you.

1

Which One Is That?

More than once, I've come home after weeks away on set, only to realize that I can't tell my kids apart anymore. Which one is the 5-year-old who's into youth soccer, and who is this one who is getting finger smudges all over my Celine overnight bag? Are they the same one? Different ones? Is there a third one that I forgot about while shooting B-roll in Estonia? This app makes this common family nightmare a thing of the past, with full files that include your child's face, name (with a pronunciation chart!), and interests, as well as quick facts like how many kids you have and how long you've had them, so you never need to have another awkward homecoming where you give a stuffed animal to one of your shorter valets by mistake.

2

So What's She Into Now?
Is It Still Gymnastics?

Kids get obsessed with new hobbies and interests at the same rate that adults use bottles of extra extra extra virgin olive oil—which is amazing and admirable, but can also be tough to keep up with. Yet despite this, most kids have no problem making you feel terrible when you mention a hobby that they're no longer interested in, often coldly informing you that they stopped being interested in that years ago, or, even worse, they were never interested in that to begin with, and you're actually misremembering a plot point from the film *Blank Check*. ➤

This great app uses a proprietary macro to skim your children's social media profiles, keeping you constantly up to date about their newest interests and hobbies. It even automatically buys them gifts online to coordinate with their new interests, to remind them that there's more to be gained in smiling beatifically at you as we go through another cookbook photo shoot than there is in whining about how "I'm 10, why would I want a DVD about learning how to use the potty?"

3

Actual Allergies

This handy stealth app (slyly hidden with a faux banking icon on your smartphone's screen) helps you keep a confidential and unhackable list of your child's actual allergies, as opposed to the allergies you made up because you wanted them to eat celery instead of Butterfingers at the movies. Download this app, and never again worry that you're mixing up the allergies that actually require medical attention with the "allergies" that require a stern Facebook post about food coloring additives.

How to Explain to Your Child's Teacher That He's Not Disruptive, He's the Reincarnation of a 12th-Century Tibetan Lama

Beginning school can be a wonderfully enriching experience for a child—the chance to finally spread his wings, explore his interests, and make friends. Most of the time, teachers love being a part of this—they got into this business because they love to watch little people grow and develop. But eventually, you'll come across a teacher who is, for lack of a better word, sour. Maybe she's jealous of your child's natural blond hair and carefree life-style. Maybe she's jealous of your natural blonde hair and carefree lifestyle. Maybe you were both in callbacks for a role in a 1989 film, and you got it and she didn't because she mysteriously fell ill the day of the final audition after eating a cup of tainted soy yoghurt that *someone* left out in the audition room. It's a given in any parent's life, so we all need to be prepared.

I recently had such a run-in in my own life, in my son Comic-Sans's second (third?) grade classroom. During parent-teacher conferences, this teacher briefed me on what she felt was troubling behavior on the part of my son, and then presented me with a brochure on a set of behaviors called the "serial killer triad." I felt, as so many parents do, that this teacher was misunderstand-ing my family, and I was confused and helpless—particularly since a close friend/mindfulness teacher/reiki coach/yoga butler had recently emerged from a weekend-long meditation trance to tell me that my son was, in real-ity, the reincarnation of a 12th-century Tibetan lama, and that's why he kept belching in math class. ➤

I talked to Irene Jamiorquai-Sanders, president of TeachAware, a non-profit, nontoxic, and non-accredited organization that teaches parents how to explain to teachers that they're wrong. Below, I give the finer points of Irene's patented T.E.A.C.H. method of interacting with teachers.

T TELL THEM YOUR TRUTH.

Though we often believe that certain teachers "have it out" for our kids, in general we couldn't be more wrong. These teachers are simply only witnessing *their* truth about our kids, which then blocks their view of *our* truth about our kids. The only way to deal with this is to gently brush their truth away, so that they can more clearly see your actual accurate truth. This point was greatly clarifying for me: Comic-Sans's teacher was seeing *her* truth when Comic-Sans told his classmates that we had a dead body in our house, while failing to see *my* truth, which is that the dead body is simply part of a much larger custom art installation Damien Hirst did for us at our ski chalet.

E EXPLAIN FACTS THAT THEY MAY HAVE MISSED.

As I discussed in a previous Glop newsletter, the death of our beloved family dog, Pier Paolo Pasolini, was a complete accident, and was in no way my son's fault—there is simply no way he could have accessed that much cocoa butter on his own. I assumed that the teacher would know this from my newsletter, but you have to assume that human error is the only constant in this world. Perhaps that edition accidentally went into her junk mail inbox. There's no need to get worked up about it; simply explain the important facts that you laid out in that edition of your newsletter, which will probably shift the conversation and end your dispute.

A ALWAYS MAKE YOUR POINT OF VIEW CLEAR.

If the previous two steps haven't quite yielded the outcome that you had hoped for, it's now time to make sure that the teacher understands your entire point of view. For me, this entailed having our maid, Lana, run a PowerPoint presentation on all the info about why my son is the reincarnation of a 12th-century Tibetan lama (i.e., similar hairlines, both have names starting with a "C," both came to me in a dream to confirm the importance of this information to me) while I made a quick phone call.

C CHECKLIST

If you're really having trouble getting through, bring a paper checklist that lays out all the changes your child requires. When I came back from my phone call, I took out my checklist, which laid out all the various homework duties that my son would need reduced or eliminated so that he could have room in his schedule for some past-life regression sessions.

H HATHA YOGA

Self-care is the most important part of any endeavor, yet it's also the easiest to forget about. Make sure to get in 45 to 85 minutes of freeing, energizing hatha yoga after a draining parent-teacher meeting.

And what should you do if you go through the entire T.E.A.C.H. method, to no avail? We ended up pulling Comic-Sans out of school in order to be privately tutored by Sir Patrick Stewart, though we also heard soon after that the teacher with whom I had butted heads went on medical leave after consuming a plate of tainted chickpea "meatballs" that someone happened to leave out in the faculty lounge.

RELATIONSHIPS

Long-lasting, mutually respectful romantic love is a lot like the moon—
we're all raised to believe that it's real and that we can see it every day.

But as life goes on, we start to wonder more and more if it perhaps doesn't exist at all, and is actually a vast government conspiracy conducted with a series of high-powered holographic mirrors.

I, like the rest of you, am still looking for answers on this front—though I've come under fire through the years for supposedly encouraging women to aspire to impossible standards regarding their bodies, hair, families, careers, financial situations, flexibility, and number of healthy daily bowel movements, when it comes to romance I'm as puzzled as any schoolgirl.

But I'm also a seeker—and in this chapter, I'll share some of the most compelling information I've come across in my own quest to understand the hows, whys, whoms, whiches, ifs, thens, yups, fleeps, and blubbles of love.

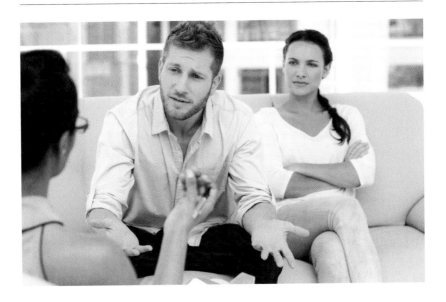

Finding a Couples Therapist Who Will Always Take Your Side

I consider couple's counseling a "last resort," something to be contemplated only after couples art therapy, couples massage therapy, couples laser facials, and an erotically charged "murder mystery party" weekend at Lenny Kravitz's château have all been exhausted. There's a reason so many of us are resistant to couples counseling: it's tough to be so vulnerable around a person you barely know—especially with your counselor in the room, too. When we visit a couples therapist but find that we can't spit out the words we came there to speak, that's our inner child telling us that it feels unsafe there—and your inner child must feel safe if you're to be honest and make any progress in a therapeutic environment. Safe from violence, safe from ridicule, and, most

importantly, safe from being disagreed with (if you have any real children, you know that they absolutely hate that last one).

How do you ensure that your inner child feels protected and sheltered in your couples therapy office? With the help of a few of our most trusted couples, couples therapists, and personal trainers, we've pulled together a list of essential questions to ask, to make sure that your time in your couples therapist's hands will be a healing experience:

"I find that one of the central, ongoing issues in our relationship is that my partner is often wrong. What do you think?"

———————

"On our way in, I was telling my partner how excited I was to get clarity from a therapist, and he told me that he believes most therapists are chronic paint huffers who kill simply to feel the god-like power of watching the lights extinguish behind another person's eyes. What do you think?"

———————

"If a train leaves Cleveland going 85 miles per hour, headed for Tulsa, yet my partner insists that the train is traveling 92 miles per hour, because he read it on his stupid iPad that he plays with for hours after I fall asleep, when will it reach Tulsa and also what specifically is wrong with my partner?"

———————

"I know one couple, the Benjamins, who seem sooooo happy" (placing two hundred-dollar bills on the table). Can you show my partner how to be happy like them? I heard they keep things spicy by inviting in some friends on occasion." (Place two more hundred-dollar bills on table.)

The Best Organic Fiber Couches to Make Him Sleep on Tonight

Real, honest romantic love is a lot like an organic fiber couch—it is made sturdy by its inherent realness; it is proof that our nature is to be true; and it is a vibrant, wonderful way to quietly telegraph your superiority to your friends who have synthetic fiber couches or use Tinder (the synthetic fiber couch of real, honest romantic love).

But perhaps the quality that makes love and organic couches the most similar is that their beauty and value lies in their flaws—a faint natural discoloration here, a suspiciously unreturned text there; an unexpected variation in texture, a text sent seven hours after a promise to "explain it all when I get home." These natural flaws provide a great way for romantic love and organic

fiber couches to truly intersect—you can use your organic fiber couch as a sacred space to give your partner room to reflect on change.

Each of these organic fiber couch materials provides a different way to tell your partner, "The nature of commitment is always changing. Also: this is really how you're going to spend your 40s, acting like a goddamned overgrown child? *I almost married Brad Pitt* and now I'm dealing with this bullshit??"

Wool

Great for: when his protestations about how that ski instructor was "just adjusting my posture" ring hollow.

Bamboo

Great for: when he "accidentally" left his wedding ring in the bathroom of Café Gratitude for the fifth time.

Jute

Great for: when you realize he deleted all your wedding photos from his laptop so that he could install Tidal.

Hemp

Great for: when you find out about his flirtations with other women from a two-star review of his headliner performance at Bonnaroo.

New Wood

Great for: "Oh, you were hiding that bracelet because you were going to give it to me 'as a surprise'? Then why does it have amethyst on it?? MY JEWELOLOGIST SPECIFICALLY TOLD YOU THAT I'M ALLERGIC TO AMETHYST'S VIBRATIONS!!"

How to Do "Sex"

In the hustle and bustle of a two-career family, it's easy to let intimacy fall by the wayside. Who among us hasn't had a moment where you suddenly realized, with shock, that it's been months since you told your partner, "Hurry up and finish, I have to attend the opening of a new rolfing gym in Silverlake at 8!"? Many of us assume that this tapering-off of desire is the "natural" course of events in any romantic relationship. But it doesn't have to be. In fact, experts agree that doing sex with our partners can be up to 1/50th as satisfying as going to back-to-back barre classes, if we simply approach it with the right mindset.

Surprised? So was I. But through the years, I've collected the tips below, which always help me get in the mood to become intimate with a partner at any time—even when sex is an imposition on a day you had already planned

on devoting to getting mani-pedis with your agent, Frigg the Old Norse goddess of wisdom, and Gwen Stefani. Yup, they're *that* good!

Drink a cup of F*ck Dirt.

Claith Dirndl is more than just a longtime spiritual mentor of mine and bad-ass working mom to a beautiful family of spiritually evolved sea monkeys; she's also the brains behind L.A.'s Cup of Dirt, an amazing natural apothe-cary-cum-smoothie spot that sells drinks packed full of Claith's amazing line of healing dirts, each loaded with essential (yet often overlooked) restorative herbs like widow's speculum, grundel bark, and chipped hair.

Claith has finally made her dirts available online, so that everyone around the world can enjoy a nice, warm glass of her vital loams at the end of a long day. Each of her supplements aims to help with a different area of life—like spiri-tuality or rest—and I simply cannot get enough of her intimacy supplement, F*ck Dirt. In fact, I always make drinking it the first step in my intimacy ritual.

Mix one teaspoon of F*ck Dirt into an 8-ounce glass of water, stir thoroughly, and sip with intention. The ingredients go to work immediately: the apple-hat extract ignites the libido, while the ground essence of wig-dumpling really scrubs at the colon, which gives you a fun thing to look forward to after-wards—it will motivate you to make it through.

Claith also sells a fabulous line of condoms spun from polenta proteins, which really make cleanup a breeze.

Assemble your tools.

Ninety-five percent of a good roll in the hay is about getting the right sup-plies, so make sure you pick them up well in advance of your date night. I like to grab some new water-repellent lingerie from Particular Larvae the day of the big event to "get in the mood"; their cheeky designs are stimulating ➤

to the eye, and keep you totally insulated from any sweat that may happen to get dripped on you. Those naughty Germans at Falco Workshop make a great line of solid gold diamond-studded dildos that cost $10,000 and really make it look like you're trying. And don't forget to tip your blindfolded cellists in advance of the big event! It's very easy to forget about it after the fact, and word gets around in the blindfolded cellist community *very* quickly.

Get your new sheets on.

Silk sheets get a bad rap as cheesy and dated; but Mme W's specially crafted silk bedware will perfectly preserve your blowout's integrity throughout the sex, whether you're lying perfectly still *or* moving around slightly. Rrrow!

Bang your sex gong.

Many of us have been using the same exact sex gong to inform our lovers that it is time to make sex love for years—one of my girlfriends has had the same one since college! Picking up a brand-new sophisticated sex gong might be just what you need to put a little more maca extract into your breakfast smoothie, *if you get my meaning*. Don Juan de Sex Gong makes some petite yet full-bodied ones that we absolutely love.

It's over!

After about 15 minutes (25 if it's the weekend!), I assume that it's over and get up to do some gentle stretches. Sometimes sex can lead to pattern dryness in combination skin, so I always try to get a jump on this by immediately applying a mixed set of restorative facial masks, each one on a different problem area of my skin. I also have one of my assistants send my partner a congratulatory text on their performance in the bedroom—Ciara Vognes makes a set of artisanal eggplant emoji ($35) that truly convey a job well done.

Sitting Very Still & Staring Ahead Blankly: For Him *and* Her

As we covered in a previous section, Sitting Very Still & Staring Ahead Blankly is the path to personal enlightenment, contentment, an increased sense of peace, and the ability to breathe underwater for up to 300 seconds.

But did you know that the tenets of Sitting Very Still & Staring Ahead Blankly don't have to only be practiced alone—that you can also bring them to your romantic relationship, to ensure that you two feel connected, experience greater unity, and are both able to breathe underwater for up to 300 seconds? It's true! With the help of Maira Gargelle, author of *The Spiritual Seeker's Guide to Deep Dicking*, I crafted this plan that can help any couple feel that soul-deep connection yet again. And the best part? You don't even have to be in the same room, or even in the same relationship, to make it work!

Empty your mind of all conscious thought (this should take 5 to 10 seconds, tops).

———

Focus on your breathing.

———

Imagine if it were your partner's breathing.

———

Slowly engage in a rhythmic massage of your genitals
that is DEFINITELY NOT MASTURBATION.

———

Continue not-masturbating long enough to have a spiritual epiphany that
feels extremely similar to an orgasm, and yet unquestionably is not.

———

Repeat after refractory period if the spirit still demands it.

SPIRITUALITY

Spirituality has interested me ever since I moved to Los Angeles in the '90s and met my first spiritual teacher, some old guy who used to hang around George Harrison.

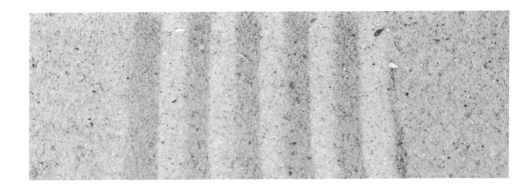

That experience set me on a spiritual journey that continues to this day—a journey that I am so excited to now share with you. In the chapter below, we truly dig into the heart of the Glop lifestyle, which I think of as a spiritual practice as much as it is a place to sell my signature bergamot-rosemary shoe perfume.

In the sections below, you'll discover the treasured spiritual wisdom that guides my life, my family, and even my skincare regimen. You may not be able to look like me, but thanks to Glop, at least you can *believe* like me.

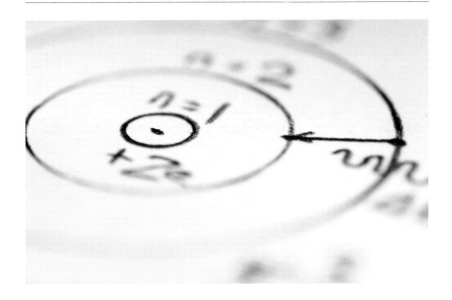

How Quantum Physics Discovered That Nothing Actually Exists & What This Means for Your Cleanse

If your dinner parties are anything like mine, you've probably been hearing a lot about quantum physics lately. In fact, recently it feels like after everyone makes the cursory five minutes of chitchat about a new charity that provides "forever" homes to abandoned endives, suddenly no one can speak of anything but the infinitely malleable nature of reality, where both everything and nothing are happening at any single moment. It's like Victoria Beckham's non-denominational adult bat mitzvah didn't even happen last week!

But people are talking about quantum physics for a good reason—while it sounds like an abstract concept that should be left to scientists in labs, in reality quantum physics affects us every single second of our lives. Yes, even when we're at hot yoga!

In fact, that was the first question I had for Guelph, Glop's resident aura reader/spiritual thought leader/intuitive gynecologist. When I met with Guelph inside her home—which is actually my 6,000-square-foot guest yurt, a lovely space furnished with bowls of luscious root vegetables, gorgeously hand-dyed floor pillows, and a TV I was considering throwing out—I was more nervous than excited about my new wisdom regarding the false facade of existence. I worried: If nothing actually exists and everything is just a pro-jection of our minds, what does it mean for our families? Or our extremely legitimate acting awards? Will it impact our souls? Or more mundane things, like, just as a random example here, the amount of money we're able to charge companies to run ads on our blogs? Guelph walked me through all of it, using an ancient, wordless teaching method that involves aura mas-sages, extended eye-gazing, and the TV I was considering throwing out. By the time we finished with our spiritual voyage, I was no longer afraid, but in fact incredibly excited to exist in a realm where reality is simply a projection (it certainly explained some of the meaner emails we've received at Glop through the years).

I wish you could all feel the majesty and wonder as Guelph summons a learn-ing circle and then performs a fable for us using shadow puppets carved from luscious root vegetables. But I'd like to give you the next best thing: Guelph's lesson on quantum physics and juice cleanses. When I went to visit Guelph, this was what I was most worried about—sure, in this reality, I was strictly following a doctor-recommended diet of juiced kidney beans, artichoke leaves, warm water, and upbeat thoughts—but what if, in another reality, there is another version of me who is eating *beef she bought at a supermarket* right this very second? Guelph could see how shaken I was ➤

when I arrived at the yurt. Would the actions of another me in another reality undo all the hard work I had done on my cleanse in this reality?

But during hour 8 of our eye-gazing ceremony, she intuited to me a powerful lesson: it doesn't matter if another version of me in another reality is eating beef with hormones in it, or even considers going to Curves for 45 minutes once a week "enough exercise." It's not why I sometimes gain up to 17 ounces of water weight in the middle of the month. Rather, I should let the knowledge that another me in another reality is not taking care of herself properly *free me*—because even though she is me, I never have to meet her. You can't put a price on the relief I felt when Guelph intuited that to me.

Your final question, I'm sure, is "What if the quantum physical structure that holds each reality separate collapsed, and then you *did* have to meet her?" Fortunately, Guelph walked me through some basic ancient philosophy on the issue that outlined the fact that, if that happens, not only do I not have to be nice to her; I don't even have to let her park in front of my house. And the same goes for each of you reading this! Our right and our bounty, as children of the universe, is to never let anyone park in front of our house.

Are You Doing Yoga Wrong or Just Mostly Wrong?

Yoga has experienced a surge in popularity in the U.S. over the past decade. Its myriad health and psychological benefits are great news for the 21 million U.S. adults who practice yoga, as well as the 42 million U.S. adults who own high-end yoga pants. There is, however, a bit of bad news to go with all this good news: doing yoga incorrectly can not only rob practitioners of its many benefits, but also create new problems, like back and neck pain, tendon strain, and "quaky bowels," and even make you vulnerable to health problems once considered eradicated by modern medical science, such as Fonzie's Disease.

Pretty scary, right? So how can you tell if you're doing yoga right or oh-so-wrong? Take our quick quiz below! ➤

ANSWER EACH QUESTION WITH A YES OR NO.

1 *Do you ever sweat while doing yoga?*

2 *Have you ever been confused while attempting a sequence in yoga class?*

3 *Has your yoga teacher ever had to do a posture correction on you during class?*

4 *Have you ever put your mat in a position that could be described as "too close" to someone else's mat?*

5 *Do you ever need to pause for a moment within a particularly challenging sequence, and engage in gentle stretching or Child's Pose?*

6 *Have you ever used blocks, bands, or other tools to help you achieve a pose?*

7 *Have you gotten compliments on your shoulder stand?*

8 *Would you describe the amount of compliments you receive on your shoulder stand as "a lot"?*

9 *Have you ever attended a special, elite yoga class where they teach you all the yoga poses that actually work, instead of all the fake ones that they teach the plebes?*

10 *Were you asked back for the weekend invitation-only retreat?*

11 *Do you know Kai?*

12 *Is he gonna make it to Kripalu this summer, you think?*

QUESTIONS 1–6:

GIVE YOURSELF ONE POINT FOR EVERY YES ANSWER.

QUESTIONS 7–12:

GIVE YOURSELF ONE POINT FOR EVERY NO ANSWER.

9–12 POINTS:

YOU ARE DOING YOGA WRONG.

You are practicing wildly incorrect yoga that could be a physical and spiritual danger to you and your loved ones. Immediately purchase *The Glop Guide to Doing Yoga Not Wrong.*

6–8 POINTS:

YOU ARE DOING YOGA WRONG.

You are practicing wildly incorrect yoga that could be a physical and spiritual danger to you and your loved ones. Immediately purchase *The Glop Guide to Doing Yoga Not Wrong.*

2–5 POINTS:

YOU ARE DOING YOGA WRONG.

You are practicing wildly incorrect yoga that could be a physical and spiritual danger to you and your loved ones. Immediately purchase *The Glop Guide to Doing Yoga Not Wrong.*

1 POINT:

YOU ARE DOING YOGA MOSTLY WRONG.

You are practicing mostly incorrect yoga that could probably be a physical and spiritual danger to you and your loved ones. Immediately purchase *The Glop Guide to Doing Yoga Not Wrong.*

Glop's Resident Spiritual Advisor, Guelph, on How Suffering Is Inevitable in This Life

We first met Guelph five years ago at a farmer's market, where she was selling slightly irregular vegetable spiralizers in order to raise funds to go to Esalen. Taken in by her silent wisdom, earthy knowingness, and naturally blonde dread-locks, we demanded that she come with us instead, and she's been our trusted spiritual advisor ever since. One of these days, Guelph, we'll finally give you that money for Esalen like we promised! We'll even let you go back for that weird-smelling dog you had that we told you to leave in the farmer's market parking lot. But until then, we're content to bask in your wisdom!

There is one thread that flows through all world religions, and it is this: suffering is inevitable. What that spiritual culture chooses to do with that knowledge varies—some run from it, some embrace it as a source of enlightenment, some use it as a premise to get you to sign up for a weekend-long retreat at some lady's house in Ojai. But all agree that no matter what prayers we offer to what gods, there is no way to not feel pain in this life.

Glop is the most spiritually evolved place I have ever labored in my life. But even here, there is some confusion about what I mean when I say that suffering is unavoidable. No matter who you are or what worldly goods you have accumulated, you will hurt, in this and every life you live.

But Is Suffering Really Inevitable in *My* Life?

I live my life by Guelph's wisdom. I run every single decision in my day by her, from what exfoliating masque to apply in the morning to what hydrating masque to apply at night, so I take her opinions and thoughts very seriously. So when Guelph said that acknowledgement of suffering was the cornerstone of every spiritual faith in all of history, I was totally game to give it a shot. But after two weeks, I had to admit: it just wasn't working! I tried and tried to suffer, to no avail. I even asked Guelph's advice on which hydrating face masque to use, and then used a completely different one, just to try to bring a little suffering into my life, but my skin *still* looked totally amazing.

So this time around, Guelph's lesson had a second lesson attached: suffering is inevitable...but also, if you try and find that you just can't suffer, don't beat yourself up over it! Today's social media culture can really make you feel suffer-shamed for your choice to have a wonderful, fulfilling, excruciatingly satisfying life—but we don't have to take it! We can stand up and proudly declare: "I feel amazing all the time! And I won't be quiet about it any longer!"

RECIPES

Cooking a clean, delicious, nourishing meal for my family is always the 43rd best part of my day (47th if you catch me during truffle season or the World Economic Forum meeting in Davos).

It helps me remember what truly matters in life—not the movies, or the TV shows, or the perfume ads, or the jewelry ads, or the purse ads, or the house in L.A., or the house in New York, or the house in London, or the other house in London, or the *other* house in London, or the secret pied à terre in Majorca, or the secret bank account in Kiev, or the awards, or the critical acclaim, or my still-new but extremely promising DJ career, or that time in 1999 when then-president Bill Clinton declared that all of that year's Oscar winners could spend 10 unsupervised minutes inside Area 51. No, what truly matters is family.

And the best way to honor that is to gather everyone around the table at dinnertime for an old-fashioned family meal. No matter what's going on with my schedule, if I'm in the same city, I make sure to make it home for dinner. Food creates feelings of connection, love, passion, and comfort. It also keeps you from passing out sometimes. It's a multi-faceted wonder product, and I am so proud to finally be able to share it with you.

Appetizer: "Fish" "Tacos"

Fish tacos are a favorite summer treat. But it's hard to feel good about eating them when you know not only how polluted our oceans and waterways are, but how many of our fish turn to hard drug use to cope. Experts who are me estimate that up to 80 percent of wild-caught salmon are tweaked out of their minds on crystal meth when caught. It's more than sad—it can impact your family's health.

That's why I developed this fresh, healthy update that utilizes plankton, Nature's oft-forgotten food group. Studies that I conducted in my pool house have shown that since plankton are generally microscopic, their hands are too small to hold drugs, let alone ingest them, making them that rare thing: sober creatures of the sea. And the fact that they're low in fat and high in protein doesn't hurt!

YOU'LL NEED:

½ pound plankton

1 cup kale leaves, de-ribbed

lemon zest

DIRECTIONS:

Arrange kale in loose "cup" formation. Add 1 tablespoon of plankton to center of kale "cup." Garnish with lemon zest. Tell your children that the only way they're ever going to see their pet bunny again is if they eat every last one of these "tacos." Olé!

BONUS: How to Boil Water

As I'm sure you've noticed, many recipes these days call for boiled water. But imagine my surprise when an assistant recently explained to me, as I prepped her for her thrice-daily farmer's market run, that boiled water is not a specific product, but rather a state of matter! Of course, there's no reason it can't be both—my first pop-up boiled water boutique will open on the Santa Monica Promenade in May, and we'll be offering mail order, as well! But if you just can't wait until then to give boiled water a try, here's my favorite recipe.

YOU'LL NEED:

2 cups water, bottler of your choice

1 Le Creuset Signature cast-iron dutch oven in Coral, Flame, or Anchor Grey

1 Viking Professional 48-inch pro-style gas range with dual ovens

DIRECTIONS:

Place water in dutch oven. Place dutch oven on a burner on the range.

Press the button that ignites the burner you have placed the dutch oven upon.

Wait until water appears sufficiently bubbly.

Salt to taste

Serves 3–4

Meat:
Roasted Chicken with Thrushed Nerfherders, Two Ways

I was on a press tour stop in Tokyo when I got back to my hotel at midnight and realized that I had forgotten to eat dinner. Where was I going to find something good to snack on? After a long day of walking the red carpet and chatting with journalists about my career as a triple threat (actress/singer/gourd whisperer), I was so exhausted, I was pretty ready to resign myself to finding something to eat in the hotel bar's carpeting and call it a night. But I forced myself to get up and walk around until I found something nutritious that I wouldn't regret in the morning.

Luckily, after a little bit of wandering, I stumbled upon a tiny, out of the way Michelin-starred restaurant. They were about to close up, but took pity on me (I must have looked quite a sight!) and roasted up a chicken more delicious than any I have ever tasted. But when I asked if they had thrushed nerfherders as a side dish, they looked at me like I was crazy—one of the small differences that separate two cultures that are actually quite similar. But I soon discovered that my luck had not yet run out—I had a baggie of thrushed nerfherders that I had completely forgotten about in my purse the whole time. I was alone in the middle of country I didn't know, but as I sank my fork into that meal, I felt like I was almost home.

This recipe was created in tribute to that magical night. It can be served solo, or on a gluten-free bun (if you serve it on a bun containing gluten, the entire meal will explode within seconds like a dirty bomb).

YOU'LL NEED:

1 roasting chicken

1 lemon, halved

3 cloves garlic, peeled and chopped

2 tablespoons extra virgin olive oil

1 teaspoon kosher salt

1 teaspoon ground pepper

1 bunch of nerfherders, freshly thrushed

1 sprig parsley

DIRECTIONS:

Preheat oven to 450 degrees.

Call in your maid, Lana, and tell her, "I've got someplace to be, can you take care of this?"

Then tell her, "Oh, and could you remember to make it two ways?"

Do something for 80 minutes.

Be served to with sprig of parsley for garnish.

Enjoy!

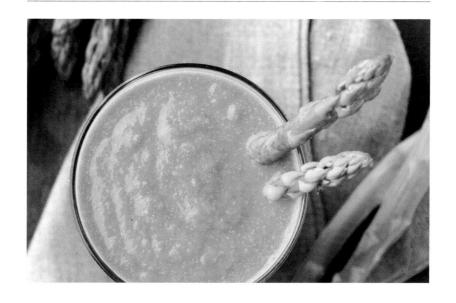

Vegetable:
Easy, Filling Asparagus-Quinoa-Sriracha-Vellum-Bee Clavicle-Bone Fragments from the Reliquary of Saint Abban of Magheranoidhe Smoothie

A while back, after months of intense overwork, I entered a period in which I felt so exhausted that I completely neglected myself—I ignored my diet, fell behind on my fitness goals, and accidentally stepped in a pile of pasta

that someone had dumped on the sidewalk. I knew that I was on the road to health ruin, and that there would be big consequences for my misbehavior—so I was terrified, but not all that shocked, when I awoke one morning believing I had gone blind. After bringing in my nutritionist, my acupuncturist, my homeopathologist, my forensic pathologist, my yard guy, and my dog's homeopathologist (he was already over for brunch) in for a long and grueling consultation, we came to the conclusion that I had not gone blind, but simply had forgotten to take off my sleep mask (House of Thibedeau, price available upon request). But still, it was just the wake-up call about looking after my health that I needed.

Now, I make sure to always take time for myself and my health—and whenever I feel things getting too out of whack, I make sure to start blending up these smoothies, which combine the rich flavor of asparagus, the filling bulk of vellum, the protein-filled one-two power-punch of quinoa and bee chest bones, and the vitamin-dense (and delish!) bone fragments from the reliquary of Saint Abban of Magheranoidhe, the high-fiber apostle of Wexford. I add or hold off on the sriracha, depending on my mood (and how spicy I'm feeling that day!).

YOU'LL NEED:

¼ cup quinoa

1 cup asparagus, chopped

2 cups water

1 cup vellum

1 tablespoon bee clavicle

1 teaspoon bone fragments from the reliquary of Saint Abban of Magheranoidhe

1 teaspoon sriracha

DIRECTIONS:

Combine ingredients in blender.

Blend on high.

Serve immediately.

Dessert:
"Vanilla" "Ice Cream" made with Rock Milk and Nut Gel

Several years ago, my spiritual advisor and holistic bikini waxer Catalina von Trout diagnosed my children, Palladium Hardware and Corthelia, with severe allergic sensitivities to everything except turmeric, free-range chicken, raw organic vegetables, and private school. I was distraught—I wanted my children to not feel different, to enjoy all the classic pleasures of childhood that their friends got to experience—without endangering their health *or* my extremely profitable lifestyle brand. Luckily, Catalina told me about this amazing recipe. The rock milk really brings out the vanilla undertones in the nut gel, making this treat one of my kids' absolute favorites. If you'd never had the real thing, you'd never know it wasn't the real thing!

YOU'LL NEED:

1 cup shelled pistachios

1 cup unsalted almonds

1 cup de-salted cashews

10–12 really solid, good-looking rocks

1½ cups chia seeds

1 teaspoon pure vanilla extract

1 teaspoon manuka honey (if you don't care about your children,
feel free to use regular honey)

DIRECTIONS:

In a large bowl, add your rocks and 3½ cups water.
Cover and let sit for 5 days.

In separate containers, soak each set of nuts in 2 cups of water for up to 2 days.
At the end of 2 days, drain each nut group. Soak your chia seeds in 3 cups of
water for a half hour, then add ½ cup of chia to each of your nut batches (chia
is a thickening agent). Blend each nut-and-chia batch in your food processor to
a fine, frothy consistency, then place in the fridge to "set" for 3 to 4 hours.

Drain and blend your rocks—I've done them in both a conventional blender
and food processor, and I find that a blender gives them a richer,
more decadent texture.

Combine your nut gels with your rock milk in an extremely large bowl and
whisk insouciantly. Add vanilla extract and honey, whisk again, then cover
and place in fridge for 5 to 6 hours. Then let the kiddos come & get it!

ENTERTAINING

What's more enriching, more enchanting, more soul-enlivening and
spirit-connecting than the act of entertaining friends and family?

Fucked if I know.

How to Find Locally Sourced, Sustainable Karaoke

Karaoke is such fun for everyone! I don't know a single person who doesn't enjoy having the opportunity to cue up their favorite song and show how much better it could have been if they had been the one to sing it. But going to a soulless, commercial karaoke club replete with pre-recorded music, tacky furniture, a cramped shared stage, and staff who have been destroyed spiritually by years of watching people sing "Semi-Charmed Life" in the wrong key can really dampen the party spirit.

That's why I like to forage for my karaoke—it's more sustainable than corporate karaoke, and doesn't make such a deep mark on our ecosphere (traditional karaoke wastes fossil fuels burned for energy, packaging thrown away in the preparation of drinks and snacks, and carbon dioxide exhaled

while trying to explain to a stranger that Third Eye Blind's Stephan Jenkins "works in the ancient warrior-poet tradition"). But sourcing more socially and environmentally responsible karaoke can be tricky if you don't know exactly what you're looking for. Here's how I find the freshest karaoke available.

Head to a heavy foot traffic area of your city where "busking" street musicians gather (in some cities, public transit centers also work brilliantly for this purpose).

Select the freshest busker available. (To see if your busker is near their sell-by date, examine the stickers on their guitar case. A busker with an Ed Sheeran sticker is probably ripe or just about there, while a busker with a Blues Traveler sticker is best left on the shelf for eventual composting.)

Once you have selected your busker, approach and begin singing along with them.

If they're playing the wrong song, simply begin singing your song over them, loudly, until their system reboots and they catch up.

Make sure all your party guests get a turn—no one likes a karaoke hog.

When you're done, thank your busker for a job well done and be on your way, awash in the good feeling that comes from making the conscious choice. (Don't worry about tipping—this wasn't business, this was about the muse bringing two would-be strangers together through the universal language of song! It's exactly what makes sustainable karaoke so satisfying.)

Tips for Throwing a Party That Screams, *"I Have Two Black Friends!"*

From time to time, we all want to host a gathering that highlights the diversity of our friend group. Maybe it's because you want your two black friends to finally meet, because you really think they'd hit it off. Maybe it's because a reporter who is writing a profile about you asked some weird questions earlier in the day about "privilege" and "white privilege" and "it's a set of social privileges that exclusively benefit and protect white people," and you're just trying to get them to focus on your new line of children's cellulite cream. Maybe you had an accidentally racist Halloween costume you need to apologize for, and you just want to invite some paparazzi to stand around in your bushes for the night so that you can get ahead of the story. Or maybe you don't have a reason at all; you just really, really want everyone to know your two black friends.

It doesn't matter why you're partying—the party tips below will easily remind all your guests that you *don't see color*, and that is why at least two black people consider you a bosom chum (if you need to convey that you have more than two black friends, see chapter 4 in our exclusive ebook, "The Glop Guide to Telling Someone How Much You Love Their Rich, Joyful Culture").

Make sure to frequently say, "My friend Shawn—oh, sorry, you probably know him as 'Jay Z.' But he's just good ol' Shawn around here!" It's OK if Shawn Carter is not actually your friend; as of this printing, there's no reliable way for your guests to check.

———————————

Prominently place any photos you have of yourself with your black friends around the party area, even if you haven't really hung out with them since filming for *Se7en* wrapped.

———————————

Talk about your intense love of hip-hop, and how this is one of the many ways that you bond with your black friends. When it seems like you've talked about it for too long, talk about it for three more minutes, then quote a lyric to a rap song. Make sure that it involves one or more of the following words and phrases, to show how serious you are about your appreciation: "fuck," "shit," "bitch," or "face fucked you in your kitchenette."

———————————

Make sure your two black friends are at the party and enjoying themselves, of course! You guys don't have to be all that close—feel free to tell them "everyone from work will be there" or "I was wondering if you could come by my house tonight to discuss our business deal, a bunch of people will be there but you can ignore them, my spouse is just having some dumb work party" if you think that will help them feel more relaxed. If you are only casual friends with one or zero black people, feel free to put out feelers within your local theatrical community for people who are willing to make non-SAG-scale pay in exchange for access to unlimited appetizers and a gift bag with bowel-detoxing tea samples in it. It's a win-win situation for everyone involved!

How to Let Leonardo DiCaprio Know That Your Carbon Footprint Is Smaller Than His

Parties are a response to one of our most basic human needs—the need to gather together and feel the kinship of our fellow humans. But sometimes, parties also serve additional human needs—like our human need to combine food resources, our need to find new mates, or our need to prove to another human that you don't get to be the best at acting *and* the best at the environment, because that would be really unfair.

In fact, paleo-therapists believe that up to 20 percent of early man's social interactions were centered around explaining how another, different early man that everyone thought was so great was, in fact, not that great (and

actually wasted an unconscionable amount of musk ox meat while village elders were not looking). So, our urges to engage in this kind of activity are more than healthy—they're natural. With that in mind, here are some tips for engaging this extremely natural urge the next time that you're, I don't know, seated at a Golden Globes table where everyone won't shut up about how Leo rescued that bear from *The Revenant* and paid for its kids to go to college or whatever.

Note that while Leo has received much acclaim for his environmental activism, his frequent international travel, by boat and plane, releases an alarming amount of CO_2 into the atmosphere—an amount of CO_2 that those of us who are not honored for our environmental activism never have to emit!

Talk about the hidden factors that influence our carbon footprint. Like the materials used to make, say, a fancy bike that someone uses to get around in an environmentally sound way. Do you think tree-elves made that titanium? Nope, it came from an earth-ruining factory! Fun fact: Saying this in front of more than two members of the press officially makes you a whistleblower.

Bring up some talking points you've prepared about carbon credits—how much do they really offset? And when someone brings 30 models onto their yacht, do we feel like they're actually buying adequate carbon credits for all of them? Is anyone looking into this? Because the lazy man who answered the phone at TMZ did not seem to understand what a great story this was!

Assemble a note written with letters cut out from a magazine that says, "I know how much water you use in your landscaping system." Very casually drop it behind Leo at a party, then loudly say, "Oh, did you drop this?" and, after inhaling through the nose and exhaling through the mouth, read it aloud in a strong, clear voice.

Call him every night at 3 a.m. and hang up. He'll claim to not know what it was about, but trust me, he gets the message.

G's Favorite Party Games

Every gathering eventually hits the dreaded mid-party lull: everyone has introduced themselves to each other already, the canapés have all been passed out, the Balinese erotic shadow puppeteers have gone home, and everyone is at a bit of a loss about what to do with themselves. That's why I always like to have some pre-planned party games handy! The 3 below are my absolute go-tos—they've rescued more parties than I can count (and once seriously saved my behind after Harvey Weinstein had an allergic reaction to my ceviche).

1

Smooth-lebrity

In the traditional party favorite "Celebrity," players write down the names of celebrities, drop them in a hat, pick one out at random, and then try to have other players guess which name they have picked—without using the actual name of the celebrity in question. I tried this at a few of my early parties, only to realize, to my total embarrassment, that many of the celebs named in the game were actually attendees. This made game play fairly unengaging. So, as a funky update, I now have all of my guests write down the name of a favorite healing smoothie on a slip of paper, and place them all in a hat. Players then have to select a slip at random, and have other guests name the smoothie *without* mentioning any ingredients; only by dramatizing its various restorative properties. It's great fun, especially around the holidays!

2

Never Have I Ever Milked

We all played this one during college/the wrap party for *Hook*, right? You list an act you've never engaged in, and everyone who has engaged in said activity takes a sip from their drink, and giggling ensues. I helped this ultimate girls' night game grow up a little by adding a new wrinkle— now we don't list things we've never done, but only things we have never milked. While this may sound limiting, it is actually shockingly flexible; we've gotten everything from "hemp seeds" to "the public's goodwill in the wake of a national tragedy that I was marginally connected to."

3

Scattergories

Remember this old favorite? In the fresh new twist I've cooked up, it's no longer about competing to think up new names for objects; it's about competing to see who can drive a Tesla into the ocean the fastest. This one never gets old!

BEAUTY

Can beauty be bought? Or is the true nature of beauty that it is part of the essence of human existence, and can only come into existence as part of a life well lived?

Is beauty a quality that cannot be captured in a jar, distilled by French people in lab coats, or injected into your naso-labial folds in what you were told would be a 5-minute outpatient procedure but it turns out that the swelling is not going to go down for quite a while? We all need to make our own decision about what beauty truly means to us, so it's not my place to tell you. It's simply my place to present you with an array of products that, if beauty does turn out to be something that can be bought, might be useful to you.

The Biggest Beauty Secret of All: Confidence (Also, Lasers)

When I was 22 and the third-billed star in several extremely successful action-dramedies, I was convinced that while my career was only going uphill, it was all downhill from there when it came to beauty. But as I got older, I realized that I could not have been more wrong.

I mean, sure, OK, back then, my skin was always soft, even though I never remembered to use moisturizer; my hair was naturally thick and shiny; and I always woke up looking like I was ready to attend a cocktail reception for the Hollywood Foreign Press Association, even if I had stayed up until 5 a.m. the night before hanging around an off-track betting parlor with the touring percussion section from No Doubt.

But despite my soft skin and pillowy lips, I felt insecure, fearful of the world around me, and anxious about losing the attention of Shane the vibraphone player—in short, my life was the very antithesis of real beauty, which stems from confidence and a sense of purpose. For most of us, those qualities only come with age, making time the ultimate beauty product.

Ever since I gave birth to my children, Pizza Margherita and Chabad, I have felt like a different human being from that silly, meek little girl—I am truly confident now, for the first time. It's confidence that shines out of every pore—the secret inner source of my outer beauty. When you see me model for a perfume ad or pose for candid shots at a party celebrating the launch of a new organic airline, what you're really seeing is my confidence.

And it's that very confidence that allowed me to pay my bimonthly visit to a beloved mentor of mine—Dr. Marcus "Bugsy" Helms, a truly evolved and spiritually attuned Beverly Hills dermatologist.

In the years since we first met at the *Vanity Fair* Oscar party, the incredibly wise Good Doctor has given me many new prisms with which to view and focus my self-confidence. Sometimes those prisms come in the form of ancient philosophical riddles meant to enlarge the spirit and enrich the mind. Sometimes, those prisms are tucked inside a machine shooting a fractional resurfacing laser, a light beam which is shot at your face to stimulate collagen production. In each case, the prisms both expand the consciousness and shrink the pores.

Now that I am finally comfortable in my own (literal and metaphorical) skin, I understand that as long as confidence is what we use when selecting our particular "beauty" products, *any choice is just as good as the others*.

In fact, one of the most important lessons Dr. Helms taught me is that if you want to be beautiful, it doesn't matter *which* prism you use; use the one that makes you feel confident, and everyone will recognize the beauty emanating from inside you. For you, the right prism to focus your self-confidence might be the joy in your child's smile; for me, it's a series of regular medical procedures that gently burn off the top layers of my skin.

But when we're true to our confidence, confident in ourselves, and secure in our power, we're all so beautiful that we each deserve our own perfume ads. I mean, not actual perfume ads. But perfume ads of the mind! We can all be the queens of our mind-perfume, if we only trust ourselves. Wait, did that make any sense? I got this intense new laser facial this morning and they told me not to drive afterwards, but I did, and I put my key in the ignition and then when I looked up, I was just here, finishing this chapter.

G's Personal Stash: Use Crystals to Distract Yourself from the So-Called "Realities" of Aging

Some people say that the march of time is inevitable, and no matter how much surgery we get or how many expensive cosmetics we buy, we're simply delaying the inevitable. I say that they have never embraced the magical healing power of buying a crystal to distract yourself every single time you feel depressed about anything, especially the quote-unquote "fact" that people who take flaxseed oil supplements still supposedly have to eventually die, just like people who have never even bothered to take flaxseed oil supplements.

Each crystal has a different profile and offers different benefits for health and spirit, so make sure to shop around to find the types that best suit you— I love kyanite, personally. But no matter what you settle on, always remember one thing: no one can force you to deal with real life, and if you spend enough time saying you have to go cleanse your crystals in the light of the full moon, no one will even try.

G's Guide to the Right Crystals for the Right Occasion

CRYSTAL	HELPS YOU
Jade	Eliminate feelings of guilt (even if they are well-deserved!)
Quartz	Hold elected office (only in Massachusetts, Ohio, Arizona, and on the Big Island of Hawaii)
Dendritic Agate	Be allowed back into the farmer's market even though the manager said it was a "lifetime ban"
Garnet	Pass your real estate license exam by the 3rd try
Quartz	Never use the wrong "it's/its"
Aquamarine	Stop talking about your collection of Dave Matthews Band bootlegs at parties where you know it will be poorly received, but you just can't help yourself
Kyanite	Develop powerful & intimidating hair
Hematite	Gain your children's respect (only in Massachusetts, Ohio, Arizona, and on the Big Island of Hawaii)

How to Purchase Healthy, Nontoxic Makeup
(from Glop)

Like a lot of young women, I always enjoyed playing with makeup. But when I got a little older and became more invested in taking care of myself, I was shocked to find out the array of harsh, illness-causing chemicals packed into even the tiniest smudge of drugstore blush. I was horrified! But as an actress/entrepreneur/spokesmodel for the National Millet Association, getting all dolled up is in my job description. I didn't know what to do, so I did what I always do when I get scared: I decided to do my own research on the thing that scares me.

And after a decade of doing round-the-clock research into makeup health and safety, I was absolutely shocked to find that the only makeup on the

market that is absolutely guaranteed to not make you develop brain tumors, lead to a mysterious health ailment called "exploding face," or cause you to grow a third, fourth, and fifth elbow, is makeup manufactured by me. I know! I was shocked, too. But it makes sense—my exclusive line of Glop brand makeup and skincare products is the sole makeup company that only uses 100% organic and non-allergenic compounds in their product, constantly monitors recipes to keep formulation up to standard, and sends all products through at least three sessions of Gestalt therapy with a certified practitioner. And no matter what you've read on some other, less credible blogs, our 100% stay-put eyeliner is not made of an unstable compound that we found on a crash-landed asteroid that seemed really healthy and natural at first, but eventually made our beauty assistant Claire's eyelids start talking and by then it was too late to recall it from stores. I mean, that would be crazy! Crazy!

I've seen Glop brand makeup change so many lives, and I am so happy and proud to help it change yours.

When Should I Throw Out My Glop Brand Makeup?

Few issues contribute more to consumer confusion than the question of when one should toss out makeup. That's why Glop decided to make it easy for you—since our makeup is made from unprocessed natural ingredients like dandelion sharts and gourd taints, it stays fresh for about two weeks, and then begins to wilt and attract gnats. For this reason, we recommend a gentle purging of your Glop beauty products each fortnight, followed by a purchase of all-new Glop beauty products.

As for your other products, don't worry—the loyalty oath that you agreed to at the bottom of our web checkout page authorized us to incinerate all of your other beauty products, and we have!

3 Amazing Skin Products You Should Have Started Using 10 Years Ago and Now It's Way Too Late for Them to Make Any Kind of Difference

When it comes to anti-aging products, it's all in the timing—as any dermatologist will tell you, it's much easier to prevent wrinkles from forming in the first place, rather than attempting to smooth them out after the fact. The three products below have been my go-tos since my early 20s, and have made all the difference in my complexion, allowing me to forgo scary stuff like Botox while still keeping a supple, youthful glow. It's a real shame that you didn't find out about them in time. Ah, well!

1

La Bandeau Printemps
Moonscreen 65

Long gone are the days when we'd frolic on the beach sans SPF (or, god help us, covered in tanning oil and with a sun reflector). But while you may feel confident in your sunscreens, did you know that our delicate skin also needs protection from the moon's brutal rays?

Yes, the moon is more than just a so-called "planet" that our government has faked a landing on. It also emits harsh rays that can harm skin elasticity. And that's not the end of it—over the past decade, prominent dermatoloticians have discovered that even a moderate level of moon ray exposure is the #1 cause of that moment where you're washing your face and you think you see a burglar out of the corner of your eye, but it's just a towel. Chilling!

Luckily, an early European co-star of mine turned me on to this French anti-moon cream, which totally shields your delicate epidermis, so I don't have to deal with any of that. Phew! ➤

2

Principessa Laboratories Applied
Skin Science Facial Program

Only available at the ultra-exclusive spa located inside the Naval Radiological Defense Laboratory, this hyper-futuristic facial (which uses a proprietary blend of saffron and lavender extract, scallop essence, sea curd, and something called "God particles") actually makes your skin unable to hold a line—it just smoothes out, like a gorgeous cashmere throw. This facial costs $120,000, and in order for it to work, you had to start doing it biannually beginning in 1995, no matter what age you specifically were in 1995.

BONUS:
What to Do if It's Too Late for You to Use These Products

If you've missed the window to use these products, don't fret—all hope is not lost! Follow our three-step plan below:

1. Begin with some gentle stretching, to warm up the lymphatic system.

2. Brew a rich cup of nettle tea.

3. Sit down in a chair and, with feet planted hip width apart, write a strongly worded letter to your parents, chastising them for not loving you enough to teach you about this essential preventative medicine (feel free to include any other issues you've been thinking about bringing up with them, too!).

3

C-500 Standing Meat Freezer

We've all heard the big recent news about cryotherapy, a trend that shocks the skin into resiliency through brief exposure to subzero temperatures. But many of us have been working with these principles for decades, by treating our skin to a restaurant-quality deep freeze each night as we doze. Regular use leaves you with taut, youthful skin all over your body and an unmistakable rosy glow—but only if you already had taut, youthful skin when you begin using it. I can't recommend the C-500 enough—especially newer models, which have emergency release latches located *inside* the freezer (those would have helped prevent a *lot* of late set arrivals back in the '90s, let me tell you).

How to Smell like Glop

People often write to us to ask, "G, what do you smell like?" Those people are all on a watchlist now. But just because I've hired teenaged Ukrainian hackers to monitor your e-mail doesn't mean that you don't occasionally have a good point. I have a striking, citrus-farmer-meets-British-aristocracy aroma that evokes fluffy Egyptian cotton towels piled high in a bathroom that doesn't actually have a toilet—and I do think it has played a large role in some of my personal and professional successes. Many people assume that this is my natural scent, which is reasonable; but like everything else about me, my scent is not the result of dumb luck, or good genes, or being in the right place at the right time to "borrow" the right script off the right coffee table while the right friend was using the bathroom—it's the result of a very disciplined daily scent routine, which I am sharing here for the first time. A gorgeous scent doesn't have to be expensive—my selections below are well within any budget, as long as you're willing to put in some elbow grease.

2 OZ. BERGAMOT

check local market prices

A lot of people buy bergamot essential oil instead of juicing the real thing, which is understandable but also personally nauseating to me. Instead, I buy a new 10 lb bag from my local organic citrus ranch each week—I only use 14 oz of bergamot juice each week, but the 10 lb bags really give you better options. Once the day's bergamot has been juiced, I gently pat 2 oz of it along my hairline.

3 OZ. GROUND, DRIED LAVENDER

check local market prices

Most of us are raised to seek shortcuts when it comes to lavender, using cheap oils and candles that have never even been near an actual sprig of *Lamiaceae lavandula*. But when we use these shortcuts, we deprive ourselves of lavender's true rich, earthy aroma. For this reason, I opt to begin each week by setting a new batch of lavender to dry, harvesting last week's now-dried plants, and grinding them with a mortar and pestle in the pre-dawn hours. I then take exactly 3 oz of the ground lavender, retreat to a secret grotto located on an unknown corner of my Brentwood property, toss the finely ground powder in the air, and caper about in its dust like a sun-sick capuchin monkey for a solid minute.

1 DROP FRESH BLOOD

free!

The smallest, yet most important part of any good morning beauty routine. Once I have scented myself with lavender in my grotto, I sit by a large, mysterious black rock placed in its center, where I gently prick one finger and smear the blood across the rock, all while chanting a soft invocation to He Who Waits. I don't know exactly how it works or what I'm doing; all I know is, before I started doing this in 1987, I was a waitress at a Checkers in Tampa, and I always smelled like burnt plastic, so this truly has become a cornerstone of my scent practice.

This all just goes to show—you don't have to be rich to look (or smell!) like a million bucks. You just need some creativity, some ingenuity, and the willingness to spend a few millennia in a lake of fire (which, coincidentally, is excellent for the pores).

FASHION

If you look at it one way, fashion is a frivolous pursuit, something that we can't possibly devote guiltless emotional space to when the environment is in crisis, Tibet still isn't free, and our country is suffering from a chalupa epidemic from which there often seems no hope of recovery.

But if you look at it another way, you have to put *something* on your body (unless you're spending the weekend at Lenny Kravitz's château)—so why not have it be cashmere jeans, a gorgeously cut pair of custom-made raw denim overalls, or a T-shirt that is made of fabric significantly nicer than what most women wear on their wedding days? Sure, the women at that food co-op you joined to showcase your earthy and participatory nature might be unkind about it. But they were already unkind when they decided it "wasn't cool" that your nanny was working all of your shifts for you, so it's kind of beside the point now, isn't it? Life has to have some pleasure in it, after all.

Socially Conscious Fashion:
I'm Still Going to Wear Leather, Though, I Mean Come On

Factory farming is an unambiguous evil—even if you're not interested in a vegetarian diet, you have to admit that they're a strain on the environment. But fake leather is also an unambiguous evil—after a few years, any faux leather item you have will start cracking, and might even flake into a plate of "paleo souvlaki" (carrots topped with radish shavings) you have lovingly prepared for your children. And in a way, isn't that just trading one trauma for another?

I mean, I'm not a monster. I understand the need for a kinder, gentler world where we all think about the long-term ramifications that our actions have

for our children, and our grandchildren, and *their* grandchildren. But leather pants telegraph a certain vibe and attitude that only leather pants can telegraph, and I really NEED to telegraph it. What do you want me to wear, wide-legged linen pants? Those clowns on *Fashion Police* would eat me alive.

Because of all of this, I was thrilled to find out about Mara Ruritable's LeatherAge collection of ultra-ethically sourced leather goods. Mara sources her leather exclusively from cows who have died of old age or misadventure on farms in upstate New York. Because of this, each of Mara's leather pieces are unique, with their own distinctive coloring, pattern of moles, teat-related stretch marks, and, on occasion, track marks. Her pieces celebrate the life and legacy of the cow or bull who gave the leather, no matter whether they passed peacefully in their sleep, accidentally ate a hallucinogenic toad and fell into a lake, or unwisely attempted to mate with a ride-on mower. It's leather we can all feel good about.

MARA RURITABLE'S LEATHERAGE LEATHER JEGGINGS

price available upon request

Everyday Basics That Cost $1,000 but You'd Understand Why if You Could Touch Them *(You Will Never Touch Them)*

While it's fun to shop for accent pieces, it's so important to have a closet full of dependable classics that can carry you through your days. In fact, I've found that most women who think they "know nothing about fashion" actually just don't have a good set of staples to work with. With that in mind, I've assembled a list of my favorite wardrobe anchors that may look like things you have hanging in your closet, but which are vastly superior because the fabric feels like the cloth equivalent of receiving a sexually charged massage from a 21-year-old Norwegian boat captain.

ISABEL QUISOTTO RIBBED CASHMERE CARDIGAN

You may think that cashmere is cashmere, but that's just because you've never worn Isabel Quisotto cashmere. If you did, you'd probably realize that most lower-priced cashmere is actually 38% actual cashmere, 50% cat fur, and 12% recycled industrial paper towels. Available in Snow White, Chalk White, Milk White, and Eggshell.

SIERRA VAN DER THON "TRISH" BLAZER

Studies done on the linen used to make this blazer have shown that even mere seconds of contact with it replicate the brain patterns most commonly seen in newborns being embraced by their mother first thing in the morning. Available in Rosemary and Plum. Oh, never mind, I just realized I got the last Rosemary one, sorry about that. Available in Plum.

AB TK THE FRENCH CARGO PANT

As these pants prove, we have the technology to make a flattering-looking cargo pant with enough pockets to fit your on-the-go lifestyle. But until those fat cats in Washington agree to provide more funding for research, these custom-fitted and hand-sewn pants will be available only to a chosen few. Available in Coal Chamber, Mudvayne, Incubus, and Len.

RICHARD RICHARD CLASSIC SCOOP NECK T

If your first relatives who crossed an ocean to get to America could touch this T-shirt one time, they would descend into a chilling spiral of madness from which they would never return. Available in Whispers, Hushed Laments, and Ecru.

LA POUPEE KITTY KAT MICRO PURSE

This tiny purse is shaped like a cat, but no one will ever say anything about it, because it costs $1,000.

HERMÈS PANTIES

Like regular panties, but from Hermès! And like some other Hermès products, they come with a lifetime warranty, which means that as they become soiled from regular use, you can keep sending them back to Paris for a delicate refurbishing by Hermès's top laundry artisans. Can be upgraded with gold or platinum hardware and diamond accents.

The Glop Guide to the Right Outfit for the Right Occasion

Having the chicest outfit in the room is no use if it's the wrong outfit for what you're doing. For example, a Valentino couture wedding gown with a full train is divine, but if you show up for enough first dates in it, you will eventually be kicked off Tinder. So it's important not just to pick the best outfit, but the best outfit for the job. Below, I've assembled a few of my favorites that go with life's most important (and best-dressed) moments.

First Day at a New Internship

Corset-topped bodice leather pencil skirt, Carolyn Humidor

So Kate pump in Nude, Christian Louboutin

Microlace high-necked button-up with peekaboo nipple paneling, Thierra Myst

HINT:

Carolyn Humidor's leather corset-topped pencil skirts telegraph
strength and power without doing a thing—which is great, because
they hold their shape best if you refrain from unnecessary movement
while wearing them. So try to avoid spending your first day doing old-
fashioned office moves like getting coffee, or breathing—instead,
stand completely still, awash in your own sense of your potential.

Your High School Reunion

Steel cage bustier with mesh inset webbing and rubberized tapes, Scythe Studios

Satin skirt in Air-Cream Green, Porpoise Mackenzie

One huge diamond

Second huge diamond

HINT:

Details make a huge impact when telling your outfit's visual story.
With this look, the second huge diamond is key in telling your story—
it shows that it's not just like you saved a ton of money for years and
eventually managed to afford just one wimpy huge diamond. ➤

First Date

Cotton/kelp sundress, Lili Q.R.C.M.-R.

Kitten heels, Lili Q.R.C.M.-R.

HINT:

This dress makes that all-important first impression by combining the comfort of cotton with the chicness and crushing, joyless environmental responsibility of repurposed kelp. Since the scent can get overpowering during daylight hours, you'll want to keep accessories simple and classic for coffee dates.

When You Have to Knock 'Em Dead at Work

Strapless silk jumpsuit in Erotic City Purple, Kreplich & Co.

Peep-toe heels in Spank Me, I'm A Bad Little Monkey Red, Reebok

Crotch accentuator by Baron von Latex

HINT:

I know! Reebok makes heels now! I was surprised, too, but they balance form and fashion in a way that will help you bowl all your co-workers over when you present your special projects!

Family Fun Day at the Beach

Purely theoretical blouse in Toasted Rumpleminz, Alice Lobberning

Seamless pescatarian robo-trousers, Lobbern Alicing

1 dried apple, Shephard's Farm of Oak Glen

HINT:

Lobbern Alicing's seamless pescatarian robo-trousers come in a variety of shapes, sizes, and colors, and I highly recommend outfitting the entire family in them! That way, you can show all the paparazzos and looky-loos at the beach that you all absolutely agree about everything and there are no problems you can't solve together, because there are no problems at all.

Solving the Cultural Appropriation Dilemma by Appropriating from Cultures That Don't Exist

We live in fast-changing times, and we have a duty to move with them, even when we'd prefer to stay rooted in the comfort of the past. For example, 15 years ago, I never could have predicted that I'd have to throw out all my business dashikis, or that wearing bindis, not as a sign of Hindu spirituality but to draw attention to your lusciously smooth forehead, would be frowned upon. And yet, here we are. It doesn't matter if you weren't trying to undermine another culture or be racist, and were just wearing cornrows because they really do look great on you—we have to be sensitive to others' feelings, beliefs, and experiences, especially in areas with high paparazzi density. ➤

For generations, wearing another culture's clothes symbolized that you were an openhearted world traveler, someone who wore native garb from a place that felt like your adopted homeland because you went to a really amazing rave there in 1997. In today's more thoughtful times, how are we to now signify that classic spirit of adventure, belief that the world is our classroom, and the fact that you totally aren't a narc? Here at Glop HQ, we've been experimenting with appropriating the classic styles of cultures that don't actually exist. These design flourishes help give outfits that "citizen of the world" flair, while also all but ensuring that no Wesleyan-educated millennial know-it-all will end up writing an angry blog post about you.

Atlantis

The versatile seashell bikini top works not only as a sea-to-sand transition outfit, but can work as a day-to-night item if you style it correctly (we like a few strands of ethically sourced pearls and a smartly cut blazer). A full fishtail is too bulky for everyday wear, but is a great touch of whimsy for a special occasion, like lounging around your luxe bedouin tent while watching Rihanna perform at Coachella.

(I checked with my Appropriation Coordinator about whether we're still allowed to use bedouin tents in this situation, and she voted yes, because there are so few Bedouin travelers in Indio at this time of year).

The Hollow Earth

There are so many vibrant cultures alleged to inhabit the planet's empty core that you can take your pick, and select the one that makes the most provocative, thoughtful, or lightly erotic statment about your personality. My favorite Hollow Earth culture to appropriate from is the proto-prehistoric culture from Jules Verne's *Journey to the Center of the Earth*, which to me signifies boldness and risk-taking, and can also be approximated with faux fur items you likely already own!

North Pole

Though many of our tackier relations have given appropriating this culture a bad name, a thoughtful dollop of North Pole—like a pop of red velvet lining inside a jacket, or boots made from the skin of a young, impetuous reindeer—can give a very simple outfit a sense of depth and texture.

Avalon

Peasant skirts with romantic layers are often considered the go-to way to show a cultural connection with the mythical UK island where King Arthur was taken after being wounded in battle—but in recent years, I've preferred to show my connection by being enveloped in a soft, misty fog. It's a fresher take, and it is wonderfully hydrating for the skin.

The Beyond

Though the basic crisp white sheet with eye holes sheared into it will always have a place in our hearts, we have found that wearing it in public will quickly make cultural appropriation the least of your concerns. Instead, we find that an extra swipe of highlighter across the cheekbones and a mini flashlight held loosely under the chin get the point across beautifully (Sonia Rykiel has some gorgeous mini flashlights this season).

HOME

The home is our most treasured space—a place to retreat from the pressures of the world, spend quality time with our families, and think about some new salads you might like to try.

But there's a ceiling (metaphorically and literally) on how relaxed we can ever feel, or how many salads we can think of, when our home isn't stocked with the right items for our family's wants and needs.

I would never tell you about the items that I currently keep in my house, because my family's home is a sacred space meant only for us (also I am currently experimenting with some New Minimalist design where the only furniture in our home is a pile of the Elephant Man's bones). But the picks below are items that my family has loved and used in the past, or, in the case of lower-priced items, were loved and used by some of my less-essential assistants—and I'm sure you'll love them, too. If you find that you don't love these picks, please know that the problem is you (for more resources, see "12 Cognitive Behavioral Therapists Who Will Teach You to Have Better Taste in Flatware," exclusively on our site).

The Only Bidets
You'll Ever Need

I try not to keep many toilets in my home—my children and I much prefer to use the fast-moving stream behind our Napa estate, which is good for the environment *and* helps us stay a bit more in tune with our bodies (my son, Candida, did once catch giardia in there, but that was mostly due to his own errors). However, as previously noted, we also love entertaining; and when you're hosting guests, certain concessions must be made—and unfortunately, offering a "bathed room" is often one of them.

But having indoor plumbing doesn't have to be a drag! Especially when you approach it as an opportunity to flex your design muscles. Your bathroom can be a showcase for your breezy, self-assured mid-century style—full of delicate whispers of silver accent, frothy mouthfuls of rich Calacatta marble, and strangled gasps of sumptuously hand-marinated glass. Take those indoor plumbing lemons, mix them with water and cayenne pepper, and make some "lemonade" that you must consume nonstop for 30 days!

No matter what your aesthetic, the star of any bathroom is always the bidet. Whether starkly Brutalist or playfully sensual, your bidet is the element that unites your bathroom concept. But with so many options out there, it can be stressful to choose the right one—who among us hasn't seen one that looked fantastic in the showroom, only to experience bidet-buyer's remorse once it has been installed? Don't worry—this is why we're here. The 5 bidets below were child-tested and mom-approved, and then also approved by members of the advisory board of *Architecture Digest*. Together, they cover all the seasons of a woman's life, functioning less like a set of 5 bidets and more like a group of warm, kind-hearted friends who provide love, support, and room-temperature water to shoot into your lower bodily cavities when you truly need it most.

1

Philippe Starck Ghost Bidet

For those looking to showcase their sense of sleek edginess in their loo, you can't go wrong with this companion piece to Starck's popular Ghost Chair. This is made from transparent injection-molded polycarbonate, turning staid traditional bidet design on its head! It does not have the machinery to connect to any kind of water supply, as that would ruin its lines and form, but you'll figure something out. ➤

2

Siena Design Perma-Clean™ Misting High-Intensity Bidet

A must-have for anyone seeking to truly clean their flowering zucchini plant, this disinfects your water supply by running an impressive 1,000 volts of electricity through your water, purifying every molecule and delivering a next-level clean. Though this bidet has been banned in both the northern and southern hemispheres, you can still pick one up from an unlicensed garbage barge parked in the middle of the equator.

3

Toshi-1252a

The bidet of the moment, the 1252a blows the 1251c completely out of the water (pardon the pun) with even lower-impact nozzles, an even higher-impact catalytic converter, multiple warming functions, and even more adjustable frequencies. Plus, they've finally worked out the bugs with the bidet's proprietary intelligent personal assistant and knowledge navigator—it no longer uses its "security function" to automatically take photos of any movement in its vicinity and then immediately post them to Facebook. Brilliant!

4

Traviatta

Looking to send the kids to your parents' house for the night and "reconnect"? This lush, nearly voluptuous, almost hedonistic piece is the perfect bidet to help reignite the passion in your relationship. From its meticulously crafted spout—which delivers an almost cushiony flow—to the paneling, which is handcrafted from reclaimed wood that once belonged to Samuel Pepys, this bidet's romantic details make it the perfect choice for a long, sybaritic weekend with your partner and a college girl you met on FetLife.

5

Bidet By Marc by Marc Jacobs

My fellow mothers of tweens will love this one! As you know, once they turn 11 or 12, there's just no pleasing your kids—while they used to love any bidet you picked out for them, now they'll tell you that any bidet you think is nice is "totally for babies" or "so boring" or "such shitty stupid trash that I literally wish Grandma had died in a war so neither of us were ever born." So surprise your middle school diva with her favorite designer's limited-edition bidet—the bright colors and polka dots provide a hit of youthful fun, while the embossed metallics give it a bit of edge that will take her right through her teen years. Let's see her try to call you a "gross withered old celery bitch" now!

Décor I Would Never Personally Buy, but Maybe It Would Look Nice in Your Smaller Home?

Over the years, I have received a lot of feedback about how many of Glop's picks are "out of touch," "completely unaffordable," "unrealistic for working families," "prohibitively expensive," "often seem to be items that have been handcrafted by Issey Miyake inside a dormant volcano on the ocean's floor," etc. I'm shocked every time, of course—when I select items to feature on Glop, I always try to include something for every price point. But it's important to make sure that all people feel seen and heard—even people who are very wrong about you, because they have probably never read your actual website and are simply going off what they read on some humorous blog.

So with that in mind, I have flouted conventional decorating wisdom, dedicated weeks to research, and picked out some gorgeous, dynamic home décor, all of it priced below $10,000. There. I hope you all feel validated now (for more on how to feel validated, check our "15 Ancient Ayurvedic Tips to Get More Likes on Facebook," exclusively on our website).

Cashmere Ottoman
$7,531

———————

Set of 3 Steel Micro-Bowls
$863

———————

Gold Decorative Brick
$3,000

———————

Steam-Powered
Heated Towel Rack
$6,032

———————

Plate to Place Bananas Upon
$2,500

———————

Set of 15 Platinum
Clam Forks
$1,200

Special Edition Sculpted
Glass Wine Decanter
(all proceeds go to reptile
diabetes research)
$2,090

———————

A Matchbook Cursed
by Martha Stewart
$5,000

———————

Juice Glass
$600

———————

The Perfect
Yacht-Mounted
Wine Mini-Fridge
(land-based version)
$9,898

How to Decorate the Wings of Your Home That You Have Closed Off

The saying "out of sight, out of mind" is the motto for most working moms— if it isn't in our way right that second, it might as well not exist. Between work obligations and family commitments, we can barely get around to firing our laziest reiki master, let alone concern ourselves with decorating the wings of our homes that have been closed off due to structural issues. The practical, no-nonsense parts of ourselves that we use to drive hard bargains in our working lives may say, "Why bother with lighting design in a part of our manse that is inhabited only by a few 100% biodynamic mice and the occasional stray wraith of a duchess?"

But while this attitude may bring us success in the boardroom, it isn't nec-essarily well suited for life inside the home. The opportunity to decorate any part of the house—even a part that has been closed off because, in order to preserve the original Victorian oak floorboards, no one can walk on them or breathe too heavily near them—is an opportunity to create a warmer, more refined home, one that truly feels like a refuge. I also have fostered a rich, mutually supportive relationship with the ghosts in each of our homes, and

believe decorating your closed-off wings is a great chance to show them that they, too, deserve a romantic, restorative sanctuary.

Try out some new styles.

In the parts of our home that our families use, "coziness" and "comfort" are generally the watchwords; however, a closed-off wing is a blank "grown-ups only" canvas in which we can "go wild," decorating with the kinds of design flourishes that adults love, but which would barely last 10 seconds with our little tykes around. I personally find that closed-off wings are a great place to try out some truly luscious experimental couches—our glass-shard couch by Bivendi, which we keep in the closed-off wing of our Tuscan estate, is one of my most beloved possessions.

Fill it with credenzas.

If you're anything like me, you have a bit of a credenza problem—nearly any time I see a beautiful one, I have to snatch it up, even though I know I already have dozens at home. A closed-off wing is a great place to finally put those credenzas to work—stagger them, layer them, or fill them with polio to honor your home's traditional Victorian design, while still invigorating it with a modern sensibility.

Play with drapery.

We have a much broader palette of drapery to work with when we're decorating a closed-off wing, since the design doesn't have to allow for free movement by occupants. And since the floors often can't support the full weight of traditional furniture, drapery must be used to express every mood and design gesture in the space—you can often capture the essence of pieces of solid furniture with a piece of impeccably colored and shaped drapery. For instance, the closed-off wing of our Malibu place has a drapery "couch," drapery "coffee table," drapery "rolltop desk," and drapery "Lalique 'Perruches' vase."

A Bunch of Expensive Fucking Pots, Just Because

As founding father Benjamin Franklin once memorably said, "A house is not a home unless it is filled with a bunch of giant hand-thrown clay pots that can't hold water but also you can't put plants in them but also don't even touch them." We've tried to pay tribute to the great man's vision with our picks below.

Herftfordtshire Ultd majolica leaf plate
$4,985

———————

Griffin Reamer-Dulcimer Workshop of Joshua Tree lava-glaze neo-cauliflower ware
$6,999

———————

Crevette Effroyable Organic Modernist Creations Jackfield deep-glaze pot
with "scary shellfish" embossing throughout
$20,001

———————

Veni Vidi Vpottery of Naples reclaimed Vesuvian serving tray
$15,586.67

———————

Charlene Tillamook Limited Edition "Giant Pot" Collection giant pot
$53, 982

———————

Cronenberg Collection malachite-and-gold "New Flesh" potter,
from their "Unspeakable Modernist Horrors" series
$9,888

———————

Vintage pot created by British peasants to celebrate a visit by
Alfonso XIII of Spain in 1922
$60,042

———————

Pot created by my son Chiarruscuro in art class
price available upon request

GIFTS

Most of us only really think about gift-giving around the holidays or on kids' birthdays—the rest of the time, we generally fall back on thoughtless ways to celebrate a friend's birthday or accomplishment, like paying for dinner or handing over yet another gift certificate for orgasmic yoga classes.

But as much as your friend may technically find an offer to pay for her horse's deworming useful, it misses the real point of the lost art of giving gifts: gifts should show how deeply you know and care about your friend, by giving her things she doesn't technically need but would definitely buy herself if she had taste as good as yours. Why pay for her horse's deworming, when you can buy her horse a Bottega Veneta black cashmere throw to wear while it's getting dewormed? That kind of thoughtfulness is at the heart of gift-giving.

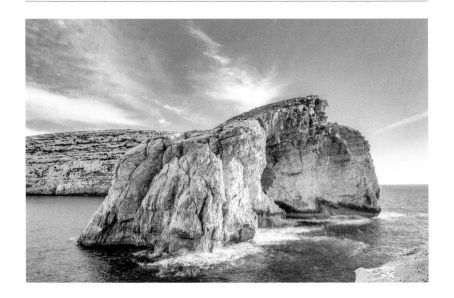

3 Gifts That Say, "Sting, I'm Sorry, Can We Talk? This Isn't Easy for Me, Either"

Learning to apologize properly is one of the most important parts of growing up. Part of apologizing properly is looking inside yourself and realizing why what you did was wrong, owning up to your shortcomings, and seeking real forgiveness with total honesty and humility. The other, more important part of apologizing properly is figuring out the exact right gift to give that will make the person you're apologizing to like you again. I recently learned a very important lesson about this in my own life, when an unfavorable mix of top-shelf gin and a private Kundalini yoga workshop led me to alienate one of my most bosom friends. These are some of the gifts I handpicked as I went on a quest to win back his confidence.

1

Vast Majority of the Country of Malta

price available upon request

When apologizing, it's important to show that you truly care about the comfort and peace of the person you want to make feel better. Sometimes, the best way to convey this is to give your friend some space to ponder what their life would be like if they cut you out of it—and if you can provide that space by purchasing it for them, all the better.

2

The Bones of Phil Collins
(*presale through private broker*)

$10,000,000

When space isn't enough, sometimes your apology gift should show how you two still share the same values—that no matter what disagreements have befallen your friendship, or how you "energetically released" your stomach contents during corpse pose, your similarities outnumber your differences. A great way to show this is to pick up a gift that will allow your friend to make good on the blood oath they took on the final night of their disastrous 2001 "King of Coming In the Air Tonight" co-headlining tour.

3

Pomegranate Me Your Forgiveness
Sorbet Gift Basket

Edible Arrangements, $33

Leave this at Stonehenge the night before Beltane. No note. He'll know.

7 Easy Hostess Gifts for the Woman Who Literally Has *Everything*

In the hustle and bustle of daily life—long days at work, followed by hours of homework help with the kids, followed by colon irrigation after colon irrigation after colon irrigation!—it can be easy to fall back on the same tired old hostess gifts for every party you attend. We all have that closet stocked with bottles of 2005 Château Lafite Rothschild, diamond-plated ram's horns that double as iPhone speakers, and golden latte machines that dispense liquid gold lattes—so the temptation to go on hostess gift autopilot is right there. The struggle, as they say, is real.

And yet, I would like to challenge you to make this year different, by putting some extra effort into your hostess gifts. You may be surprised to see how friendships bloom when you express, through a simple gift, that you know something about your hostess and care that she feels pleased with her gift. And if you feel like you don't even know where to start, I'd like to recommend some counterintuitive hostess gifts that have turned many an acquaintance into a true pal for me over the years.

1. 15 ENGRAVED LALIQUE VASES

Lots of people show up with armfuls of Lalique vases to these things, but who is forward-thinking enough to jazz them up with chic engravings of stuff like your hostess's initials, astrological symbol, or emergency contact info? You, now!

2. ROUGH DRAFT OF THE ORIGINAL SCRIPT FOR *STAR WARS*, WITH AN ALTERNATE ENDING WHERE HAN SOLO ENGAGES IN SOME ENTIRELY JUSTIFIED CANNIBALISM

Who doesn't like owning a piece of history?

3. A URANIUM MINE IN LOST CREEK, WYOMING

Cheeky!

4. PAINTING OF THE LAST SUPPER WITH YOU AS ALL OF THE CHARACTERS

Guaranteed to only appreciate in value.

5. ONE HEALTHY GIRAFFE

If this is not available, two slightly sick giraffes is considered an acceptable substitution.

6. PUBLISHING RIGHTS TO "ROCKY RACCOON"

Now available from SkyMall, for those of you on the go!

7. BROOKSTONE PIZZA STONE

For when you have no idea about a hostess's personal tastes and just want to err on the side of caution. Don't assume that you know what she likes. When you assume, you make an ass out of you and M.E. (Melania Elvira, my gifting doula).

Birthday Gifts for Your Friend Who You Know Wants a Cartier Watch but You Don't Think She Deserves It

We all have that "problem" friend—someone who weaseled her way into our social circle when we weren't looking and whom we are now required to purchase gifts for on her birthday. Predictably, this friend is always eyeing your pink gold and diamond Cartier Tank Francaise watch, dropping hints asking about your relationships with the staff at the Cartier store, sending you texts asking you to buy her a pink gold and diamond Cartier Tank Francaise watch for her birthday, etc. Below, discover 7 birthday gifts that say, "Drew may like you because she is a very trusting and forgiving person, but I, personally, remain unconvinced."

1 *A $20,000 donation in her name to the Butt Disorders wing of the Johns Hopkins Institute for Biogenetic Research*

2 *Taxidermied foot of the real-life elephant who inspired Babar (comes with a certificate of authenticity confirming that he did not die naturally)*

3 *Partial ownership of the San Diego Chargers*

4 *Andy Warhol's Electric Chair, unframed and slightly creased*

5 *Pink gold Cartier Tank Francaise watch without diamonds*

6 *One-year membership at Careless Whispers, Cleveland's most exclusive sex club*

7 *A 30-minute one-on-one meet-and-greet with Omarosa*

What to Buy for Your Friend Who Lets Her Kids Eat White Flour

We all have someone in our life whom we feel deep affection for, despite the fact that they exhibit a criminal level of disregard of their children's glycemic index. Perhaps you're connected to this person by accident of birth; maybe you're just hanging around because you're waiting for the right moment to discreetly take a photo of her serving orange soda to her children, which you will then forward to Child Protective Services. Either way, you still need to figure out the right items to give her for birthdays and holidays that say, "I'd get you something nicer if I believed that you knew how to properly milk a cashew, you ghoul."

> **BONUS:**
> ### What to Do if Someone Buys YOU $200 Candles
>
> In the past, whenever I unwrapped a gift box to find that it contained $200 candles, I immediately started making plans to donate them to a children's charity, even as I was "thanking" the person who had gifted them to me. But then, I learned this life-changing pearl from my scalp manager, Peony-Skylar LaFargo—and my gift-accepting life has never been the same!
>
> 1. Take your $200 candles
>
> 2. Place them into $10,000 candleholders
>
> Voilà! Now your candles look like they cost at least $500, meaning you can confidently place them in your servants' garage, second prep kitchen, or the only bathroom your landscapers are allowed to use.

THE ORIGINAL TINY PURSE BY SARARARARA
$450

Sarararara is at the forefront of the "tiny purse" movement, which is about simplifying your life by only filling it with things that truly give you joy—and then shoving those things that give you joy into this 3 x 4-inch purse. This gift might encourage your friend to be more conscious and deliberate about her existence; also, there is no room in it for Cheez-Its.

$200 CANDLES BY TERRIER POUVOIR
$205

The cool thing about Terrier Pouvoir candles—created on a Dutch lavender farm by a French ex-banker who left New York City so that she and her family could have the space and peace to fully appreciate their window treatments—is that, in addition to their line of cheap crap for awful losers, they also have a really great selection of luxe hypoallergenic soy candles, in case you're in the mood to pick up a little something for yourself.

ECO-WEEKENDER TOTE BY REMOTE UVULA
$500

These chic weekender bags, fashioned from repurposed uvulas of long-dead whales, are stylish AND they teach a lesson about how to honor our earth (instead of eating things that make it seem like your friend doesn't even understand the differences between the majestic human body and a tarp filled with dumpster water, *which are many*).

KIDS!

Every single year, my appreciation and grasp of what it truly means to be a parent expands, matures, and changes. I accomplish most of this growth through dedicated spiritual study with excellent teachers abroad, sometimes for months at a time if that's what it takes to truly understand the real psychological tenets of parenting.

This schedule, of course, is terribly hard on my children, whom I usually see for about 6 days a month (10 tops, and that's only when I don't have a new detoxifying charcoal suppository to promote that season). So, like any busy working mother, I like to make the most of the precious little time we have together. We're more than just our children's protectors; we also are their very first models for how to interact with the world, weathering its disappointments and celebrating its moments of joy. And so I like to spend our time together passing on my most cherished values in my family's most time-honored way: buying stuff. This section is a bit briefer than the others because children are smaller than adults, so you don't need to put as much thought into what you buy them (it's math).

4 Endangered Species Protection Society Memberships to Get Your Children Instead of What They Really Want

Like so many kids, my own two towheaded angels have spent years desperate for a puppy. But while raising a dog can be a rewarding experience, my third personal assistant/pet consultant, Deborah Shannen-Jaws-Shannon, has advised me that having a dog running around the house would absolutely undo all the root chakra work we've been doing. Plus, when we give our children everything they desire, we deprive them of the wonderful gift of being unhappy and then figuring out what to do to kill the pain—one of life's most essential skills.

With all of this in mind, every year I give my kiddos a new membership to an endangered species protection society, to remind them that the world is bigger than just their immediate sphere; that the less fortunate need their help; and that animals are best enjoyed from afar.

1. WORLD WILDLIFE ORGANIZATION

This great group has live cameras placed throughout the rainforest and jungle areas around the world, so your kids can log on any hour of the day or night and see panda bears, orangutans, or baby elephants that look like they're practically in your living room. Yes, dogs may offer shy and nervous kids a sense of unconditional love in an uncaring world, but surely the wild animals seen in this live cam would also feel unconditional love for your kids if they met them (that is, if Nature had not programmed most of them to mistake your child for a rival animal intent on stealing their young, leading them to rip your tot limb from limb).

2. PANDA KLUB

Looking to teach your kids about responsibility the way that walking and caring for a dog might? Then you're in luck—this conservation group can have their members' fees billed directly to your child, and if they forget to pay on time, Panda Klub WILL turn their account over to a collections agency.

3. WALT AND JENNY'S ANIMAL SAVERS—TULUM

Walt and Jenny are a wonderful couple who travel the world defending and protecting animals who are under siege due to environmental or human threats. Their Tulum, Mexico, outpost unfortunately doesn't have any actual animals on-site, but it is located next to a great massage place, and also Walt and Jenny once personally helped me talk a nanny down from a bad salvia trip.

4. TOM FORD

Tom Ford is less an endangered species protection society in the traditional sense, and more a visionary designer whose breathtaking tailoring and eye for texture makes him a national treasure. But the hardest (and yet often most rewarding) part of parenting is teaching your kids that what they want and what they *need* are sometimes two very different things—and they need to get some nicer shoes if they think they are going with me to the People's Choice Awards this year, I am *serious*.

4 Best Caviarz for Kidz

Though I like to keep an eye on sugar, salt, and preservatives in my little ones' diets, I don't deprive my kids of all the classic treats of childhood by any means. Sometimes, being a great mom means letting your kids live a little, you know? And so, on a balmy summer afternoon, there's nothing my brood likes better than gathering together on the back deck and chatting about the shenanigans and monkeyshines they got up to that day with their nannies and assistant nannies while we all cool down with a nice plate of caviar. When I see the looks on their faces as they shovel down that Kazakhstanian beluga roe, I know I can't deprive them, even though the sodium is off the charts. There are, after all, only so many summers of childhood!

My grocer is great about keeping stocked up on the brands of caviar that kids crave, but I know that many parents are not so lucky. There's no need to turn this into another dinner table standoff, though—we've handpicked the best caviars that keep kids happy (which is the real secret to keeping parents happy).

1

Bill's Shassetra

Bill is a father himself, and understands how important it
is to serve our kids sustainably and ethically harvested fish
eggs—not only for our values, but for their futures.

2

Millicent Farms Russian Sturgeon Caviar

Millicent Farms offers the best of both worlds: *Caviar Aficionado*
named it "the champagne of caviars," yet its playful, smoky flavor
will grab the taste buds of even the fussiest snacker (who is
accustomed to regularly consuming grade 1 Russian caviar).

3

Gaston Beareuth Royal Caviar

"Royal caviar" is a term that means a golden roe, which is only produced
by 1 in 1,000 sturgeon. I love to pack this one for their lunches, because
its yellow hue is such a fun cafeteria conversation starter!

4

Fresh Sturgeon from the Caspian Sea

Of course, if you really want to give your kids one of the classic experiences
you remember from your own childhood, you'll want to take them out
on an Azerbaijanian fishing boat, where earthy fishermen will scoop up
some roe right from the source. Done properly, this trip can not only
expand your child's palate, but also make up for accidentally leaving
them in Istanbul for 72 hours during the *Iron Man 3* press tour.

Family Fun Picks from My Children, Perforated Hespadrille and Choade

We can get so busy trying to be perfect parents—getting our children into the right schools, sending them to the right extracurriculars, buying them the right Cessnas—that we often forget that the real point of having kids is spending quality time with them. It's so important to remember to just relax with our kids, and do the things that *they* like to do. My kids, Perforated Hespadrille and Choade, have had strong personalities and vivid tastes practically since they came out of the birthing pool, and whether we're on the go while I'm at work, or spending a lazy Sunday making our own stevia, I make sure to include things that reflect their own interests and satisfy their curiosities. Below, PH and Choadey share some of their favorite kid stuff.

The Ingmar Bergman Trilogy Boxed Set
(*Through a Glass Darkly / Winter Light / The Silence*)

Every time PH has some friends over, she loves to toss on a disc
from the set that the Criterion collection calls an "evocation
of a desperate world confronted with God's desertion."

Diamanda Galas, *Plague Mass*

Choadey got me into this one, and now we pump it on every family
road trip! His favorite track is album-opener "There Are No More
Tickets to the Funeral," but I prefer the deep-cut track "How Shall Our
Judgement Be Carried Out Upon the Wicked?," especially if I need
to get psyched when I'm doing my last set of reps at the gym.

Watership Down, by Richard Adams

Choadey says, "I love the bunnies. They are so silly.
Sometimes I wish I could go away forever, too."

AffirmME! App

PH is just *addicted* to this app, which provides users with uplifting daily
affirmations, like "The present moment may be a prison, but it is a brief moment
in the eternity of the spirit." I can barely pry it out of her hands at dinner!

Traditional Vodun Doll

I actually don't remember buying this for the kids, but they can't
seem to get enough of it—and when the kids are happy *and* learning
something about another culture, I'm always over the moon. The doll is
made of bark, and appears to have some of my hair glued to the top, as
well as some pins stuck through it, proving that, if you take them away
from all those screens, kids still possess infinite natural creativity.

Loo

LOOK AT

Glop isn't just about the things you eat, wear, or smudge sage around; it's also about being a citizen of the future, and finding the greatest culture for your family everywhere you go.

In fact, part of the reason I founded Glop is that I wanted to find a way to share all the great advice and information I had picked up over the course of my many travels.

You shouldn't be going to some artisanal wind salon or restaurant that only serves water that carrots have been boiled in, just because your hotel concierge recommended it (especially since they're only recommending it because they're getting a kickback); you should be going to the absolute best artisanal wind salon or carrot-water restaurant in town! So I'm pleased to be able to share my best "not for tourists" picks that will make you feel at home no matter where you find yourself.

The Glop Guide to Spending a Ton of Money in Paris

There's truly no place on earth like the City of Lights! Few other cities can match Paris's history, romance, and ability to make visitors feel like they are constantly being judged. Because of all these features, Paris has always felt like a second home to me (and is, coincidentally, the site of my ninth home). The ancient Gothic churches! The gorgeous public parks! The train system that I hear people who don't have cars like to use! It all makes for a world-class visit, every time.

The best parts of Paris manage to combine the Old and New Worlds in fascinating ways—and allow you to instantly understand why this useless, carb-filled city still manages to charm pretty much everyone who visits.

Dine

CRUEL PIERRE'S GRUEL BOWL

It's true, French women don't get fat—and Cruel Pierre is why! French food is some of the best in the world—but it's also some of the worst for you. That's where C. P. comes in; his fresh, high-protein spins on traditional French gruels have been helping Gloppers enjoy their trip to the City on the Seine (without ruining their diets) since 2002. The menu changes daily, based on what C. P. and his staff find on their daily trips to Paris' legendary early morning gruel markets—so one visit may yield a tasty leek-and-microgreens gruel, while the next might find you sipping on some gruel infused with wild-caught cod. And if you get tired of gruel, don't worry—Cruel Pierre offers plenty of lively side dishes, like a plate of rock salt that Pierre personally forces you to eat all of. C'est magnifique!

Visit

PÈRE LACHAISE CEMETERY

Père Lachaise is the largest and most famous cemetery in Paris—which is really saying something in a city famous for being filled with the decaying remains of society's most beloved cultural figures. Père Lachaise is the final resting place of everyone from Oscar Wilde to Maria Callas to Jim Morrison—and me, sometime within the next 60 to 100 years (depending on the pace of innovations in the fields of laser dentistry and kale injection technologies).

Every time I'm in Paris, I love to come and visit the grave plots I have purchased for myself, my children Pawtucket and Charro, and an as-yet-unknown lucky future Mr. Glop! (In the event that we are unable to source a Mr. Glop in time, the spot will be filled with the body of our beloved family dog, Pier Paolo Pasolini.) Buying a group plot in Père Lachaise is a classic Paris experience, and something every family should do at least once. So make sure to plan your trip on a weekday, when the office is open. And come say hi to our plot while you're at it—we're right behind Honoré de Balzac! ➤

Shop

CHRISTIAN LOUBOUTIN PARIS FLAGSHIP STORE
MATERIALS SHOWROOM VIP TOUR

Paris (or "Paname," as the young people call it) is a famous international mecca for shopping —you can get the best of the best from every designer in the world within the city limits. But I think it adds a special element to the experience when spend your time in Paris shopping with one of the city's own—which is why I love my yearly trips to the Christian Louboutin Paris Flagship Store Materials Showroom VIP Tour ($1,000). Though Louboutin's signature red-soled heels are a staple for stylish women the world over, it all began here, and this one-on-one exclusive tour puts you face-to-face with the raw creativity at work in the brand.

Tour guests will be taken to a hidden nook of the shop, where you'll get to spend up to an hour examining the raw leather and cans of red paint that eventually become the world's most elegant shoe (the cans are unopened, but the color is clearly labeled on the side). Make sure to stay in close contact with your tour guide, though—last time I went, I thought mine had just left to use the bathroom, but he had actually accidentally locked me in there over a three-day weekend (the French love their holidays!).

Stay

MY APARTMENT IN PARIS

My home in the 16th arrondissement is absolutely one of my favorite spaces in the world—it's so peaceful, while still being steps from the thrilling hustle and bustle of the city, and always filled with gorgeous afternoon light. It's a wonderful place to unwind—having your own apartment, filled with your personal belongings, makes travel a pleasure instead of a chore. You should think about getting one!

Watch

8TH ARRONDISSEMENT COMMUNITY PLAYERS
PRODUCTION OF *SHEAR MADNESS*

It's in French! Adorable!

View

FULL/STOP BY AARON JONES AT
GALERIE LUCIE BERNAISE

I met Aaron at a silent SoulCycling retreat in Nice and was immediately struck by his passionate personality and vibrant man-bun. Aaron told me he was a painter who specialized in "dynamic pigment-based energy transfer," painting "soul portraits" of notable men and women with organic and nontoxic dyes tailored to their aura palette. He asked me to sit for a portrait and I of course said yes! His images of me, and many others, are currently up at Galerie Lucie Bernaise. I didn't get a chance to go the last time I was in Paris, because we were getting our bathroom redone and you really have to stick around and make sure that they do the tiling right, but I have a really good feeling about it, so you should totally go.

10 Must-See TED Talks to Expand Your Horizons Without Ever Leaving Your Sensory Deprivation Chamber

TED Talks are to our modern world what epic poems were to medieval people—a way to not only become informed about the world, but also solve our greatest problems. I always look to TED Talks for guidance about work, love, spirituality, and ways to use the word "innovate" to describe paying strangers to do chores for me—and they never let me down. And I find them especially useful during my daily dip into my sensory deprivation chamber—I know that when you're floating around in there, you're supposed to let your mind go completely blank as you reconnect to the primal nexus of humanity, but sometimes I'd really just rather watch something on my phone.

1

How Mops Work

BY CHARLOTTE BAZINGRA

If, like me, you've heard a lot about mops but were just never clear on the mechanics, this illuminating 40-minute talk will clear it all up.

2

Is Gluten the Cause of Global Warming?

BY BRYN TALCUMM

This brave talk speaks the truth that the corporate-controlled media is too scared to print.

3

Can You Help Your Sweaters Have Higher Self-Esteem?

BY CHAZZ CAFTANG

Absolutely essential viewing, even for people who don't own any sweaters!

4

You've Been Showering Wrong This Whole Time

BY TINA JAGOV

Discovering that you've been doing something so wrong your entire life is terrifying, but it will also set you free. ➤

5

How I Learned to Accept My Flaws

BY GISELLE FLURGHEIMER

Supermodel Flurgheimer's struggle to accept herself (and
the shocking revelation of her webbed toes) will connect
with anyone who has ever felt imperfect.

6

Slow Breathing

BY MILCH FUGLER

If you've had your life changed by slow food, slow architecture, slow fashion,
and slow travel, this thrilling new slow movement will blow your mind.

7

Am I Barry Manilow?

BY LARISSA CAPOEIRA

Evolutionary hypnotherapist Capoeira fuses interactive technology,
modern dance, and confessional slam poetry to explore the
question we each carry inside ourselves: Am I truly myself? Or
am I actually Barry Manilow, and just don't know it?

8

I Broke My Jaw

BY JAY LEPIESSEN

Thought leader Lepiessen breaks the fourth, fifth, and sixth wall as well as his own jaw in this mind-bending talk, where he severely damages his entire mouth while graphically choking on a stale lozenge.

9

Taboo Was the Best Member of the Black Eyed Peas

BY DANICE PRESSUPOSE

After watching this multimedia presentation, you'll never look at Fergie the same way!

10

You Are Human Garbage and You Need Me to Lead You

BY GLENDOLYN POULTRY

This engaging talk peels away the layers of artifice in society and gets to an essential yet hard-to-admit truth: you are a trash person who was raised in a toilet bowl, and without my guidance, you will surely perish. To be adapted into a book for release in fall 2018!

How Will Glop Change Your Life?

As I said earlier, Glop is a website, a business, a state of mind, a philosophy, and a really solid tax shelter. But it's also a tool. Like the Bible, *The Da Vinci Code*, or *Skinny Bitch*, Glop can only serve up the essential spiritual truths—it's your job to decide whether you'll liquefy them in your blender and actually consume them.

Will you discard the things you learned in this book, like last year's Lexus? Tossing off excuses about how they were too "real" or you "didn't have time" or they "didn't make any sense, even when I read the same paragraph several times"? Or will you be brave and put them into action, transforming your life and maybe even becoming a celebrity lifestyle guru in the process? Ha ha, just kidding about the last bit (it's part of a celebrity lifestyle guru's job to have an excellent sense of humor). But with the tips in this book, you *can* transform yourself and your life. I hope you take what you've learned within these pages and become a healthier you, a happier you—or at the very least, a more digestively regular you. I hope you'll remember the times we shared in these pages, helping you look deep inside your own soul. And I hope you'll remember that lending this book to a friend is basically the same as stealing, and may be prosecuted as such (pending the success of my Senate bid). But more than anything, I hope you'll always cherish your memories of what it was like spending all this time with me—your favorite person.

Most of my love,

G

Acknowledgments

No one writes a book without any help from others—trust me, I really tried. However, in the end, I found that I still must thank:

Sean Newcott, Carrie Thornton, Emily Homonoff, and everyone else at Dey Street Books, for understanding that the world was finally ready for my wise, earthy musings about colon hydration; Alison Lew and Lisa Story for making sure that my book was pleasing to the eye *and* did not contain any embarrassing misspellings of the word "ashram"; and Bianca Consunji, for managing to capture both of my good sides in my author photo.

I owe much gratitude to Team Glop—Anna Parsons, Arielle Dachille, Benjamin Hart, Emma Lord, Erin Mayer, Mary Grace Garis, Kathryn Kattalia, and Simone Meltesen—who make sure that I wake up each morning to a flawlessly prepared acai bowl. I have never met any of them in person, but am certainly open to doing so in the future, under the right circumstances.

I must thank my senior quinoa consultant, Lauren Bans, who was the first person to tell me that I had a duty to commit my moisturizing routines to the historical record. I would also like to extend appreciation to my spiritual advisor/transcendental manicurist, Julie Alvin, who said, "Hey, are you game for steaming your vagina?" Further thanks to Steph Georgopolis, Jia Tolentino, Sarah Mirk, and Margaret Eby for taking early chances on the writing of a young, scrappy, unproven Academy Award–winning actress.

I would like to express deep gratitude to my father, Dan Molerio, for not being mad that I am way more famous than him.

And Jesse Rifkin: you are the stars to my night sky, the yin to my yang, the Edge to my Bono. I am finally ready to forgive you for what happened at Lenny Kravitz's château—please come home.

Author Bio

GABRIELLE MOSS lives in New York City, where she once tried to go on a juice fast (she made it through the first five hours, then ate a burrito). Her writing has appeared on *Slate*, *GQ.com*, *The Hairpin*, *Bitch*, *the Toast*, *Bustle*, and many other fine websites. Follow her on Twitter @gaby_moss.

PHOTO CREDITS

DESPERATELY NEED EVEN MORE GLOP IN YOUR LIFE?

Pick up some of our exclusive e-books:

The Glop Guide to Ethically and Sustainably Sourced Oxygen

———————

10 Fun Stem Cell Moisturizing Repair Masques to Make at Home

———————

Is Listening When a Police Officer Says, "Ma'am, I Am Not a Valet, and You Have Driven Through the Front Window of a Walmart" Toxic?

———————

Restorative Yoga Poses for When Sting Is Mad at You

———————

The Glop Astrology Guide to Buying the Right Birkin Bag